THE SAINT JOHN'S BIBLE

The Saint John's Bible is the first completely handwritten and illuminated Bible to be commissioned by a Benedictine abbey since the advent of the printing press more than five hundred years ago. It was created entirely by hand in Wales using ancient methods, materials, and tools, including turkey, goose, and swan quills and pigments made from hand-ground minerals and precious stones. Comprising about 1,150 pages—measuring 15 7/8 inches wide by 24 1/2 inches tall—and more than 160 beautiful works of art, the Bible is seven magnificent volumes and will be bound between boards of quarter-sawn Welsh oak.

The creation of this one-of-a-kind Bible was a fifteen-year process from its planning to its completion in 2011. Renowned calligrapher and illuminator Donald Jackson served as artistic director, collaborating with scribes, artists, and theologians to hand-create the stunning lettering and exquisite illustrations that fill the volumes and enliven and make new the Word. Each illumination is its own work of art, individually designed and painted by hand, that will inspire the faithful and thrill anyone who appreciates artistic beauty.

This lovely calendar features a different one of the Bible's colorful and intricate illuminations on each weekly spread. This beautiful calendar is one that will find a place on bookshelves long after the year is over.

Visit www.saintjohnsbible.org to learn more.

**Andrews McMeel
Publishing, LLC**
Kansas City • Sydney • London

Illuminate:\vt\ from *in* + *luminare* to light up, from *lumen* light. 1a: to enlighten spiritually or intellectually b: to supply or brighten with light; 2a: to make clear b: to bring to the fore; 3: to make illustrious or resplendent; 4: to decorate (as a manuscript) with gold or silver or brilliant colors or with often elaborate designs or miniature pictures.

Donald Jackson, renowned calligrapher and illuminator, served as the artistic director of *The Saint John's Bible*. The following is a list of the artists and scribes with whom he collaborated to create the script and illuminations contained within this calendar. Due to space constraints, we are unable to directly attribute each work of art and script to the respective artist. To learn more about Donald Jackson and his team, please visit *The Saint John's Bible* Web site: www.saintjohnsbible.org.

Illuminators: Donald Jackson, Hazel Dolby, Aidan Hart, Sue Hufton, Andrew Jamieson, Thomas Ingmire, Susan Leiper, Suzanne Moore, Sally Mae Joseph, Diane von Arx, Angela Swan, Chris Tomlin

Scribes: Donald Jackson, Sue Hufton, Sally Mae Joseph, Izzy Pludwinski, Brian Simpson, Susan Leiper, Angela Swan

The Saint John's Bible 2013 Calendar © 2012 Order of Saint Benedict.
Printed in China. No part of this calendar may be used or reproduced in any manner whatsoever without written permission except in the case of reprints in the context of reviews. For information write Andrews McMeel Publishing, LLC, an Andrews McMeel Universal company, 1130 Walnut Street, Kansas City, Missouri 64106.

www.andrewsmcmeel.com

ISBN-13: 978-1-4494-1732-1

2013

January

S	M	T	W	T	F	S
		1	2	3	4	5
6	7	8	9	10	11	12
13	14	15	16	17	18	19
20	21	22	23	24	25	26
27	28	29	30	31		

February

S	M	T	W	T	F	S
					1	2
3	4	5	6	7	8	9
10	11	12	13	14	15	16
17	18	19	20	21	22	23
24	25	26	27	28		

March

S	M	T	W	T	F	S
					1	2
3	4	5	6	7	8	9
10	11	12	13	14	15	16
17	18	19	20	21	22	23
24	25	26	27	28	29	30
31						

April

S	M	T	W	T	F	S
	1	2	3	4	5	6
7	8	9	10	11	12	13
14	15	16	17	18	19	20
21	22	23	24	25	26	27
28	29	30				

May

S	M	T	W	T	F	S
			1	2	3	4
5	6	7	8	9	10	11
12	13	14	15	16	17	18
19	20	21	22	23	24	25
26	27	28	29	30	31	

June

S	M	T	W	T	F	S
						1
2	3	4	5	6	7	8
9	10	11	12	13	14	15
16	17	18	19	20	21	22
23	24	25	26	27	28	29
30						

July

S	M	T	W	T	F	S
	1	2	3	4	5	6
7	8	9	10	11	12	13
14	15	16	17	18	19	20
21	22	23	24	25	26	27
28	29	30	31			

August

S	M	T	W	T	F	S
				1	2	3
4	5	6	7	8	9	10
11	12	13	14	15	16	17
18	19	20	21	22	23	24
25	26	27	28	29	30	31

September

S	M	T	W	T	F	S
1	2	3	4	5	6	7
8	9	10	11	12	13	14
15	16	17	18	19	20	21
22	23	24	25	26	27	28
29	30					

October

S	M	T	W	T	F	S
	1	2	3	4	5	
6	7	8	9	10	11	12
13	14	15	16	17	18	19
20	21	22	23	24	25	26
27	28	29	30	31		

November

S	M	T	W	T	F	S
					1	2
3	4	5	6	7	8	9
10	11	12	13	14	15	16
17	18	19	20	21	22	23
24	25	26	27	28	29	30

December

S	M	T	W	T	F	S
1	2	3	4	5	6	7
8	9	10	11	12	13	14
15	16	17	18	19	20	21
22	23	24	25	26	27	28
29	30	31				

THE GOSPEL ACCORDING TO JOHN

1 IN THE BEGINNING
WAS THE WORD AND
THE WORD WAS WITH
GOD, AND THE WORD
WAS GOD. **2** HE WAS IN
THE BEGINNING WITH
GOD. **3** ALL THINGS CAME
INTO BEING THROUGH
HIM, AND WITHOUT
HIM NOT ONE THING
CAME INTO BEING. WHAT

December 2012

S	M	T	W	T	F	S
						1
2	3	4	5	6	7	8
9	10	11	12	13	14	15
16	17	18	19	20	21	22
23	24	25	26	27	28	29
30	31					

January 2013

S	M	T	W	T	F	S
		1	2	3	4	5
6	7	8	9	10	11	12
13	14	15	16	17	18	19
20	21	22	23	24	25	26
27	28	29	30	31		

Dec-Jan 2013

Monday
31

Tuesday
1

New Year's Day

Kwanzaa ends (USA)

Wednesday
2

New Year's Day (observed) (NZ)

Bank Holiday (UK—Scotland)

Thursday
3

Friday
4

Saturday
5

Sunday
6

JOHN

And the Word became flesh and lived among us, and we have seen his glory, the glory as of a father's only son, full of grace and truth. (1:14)

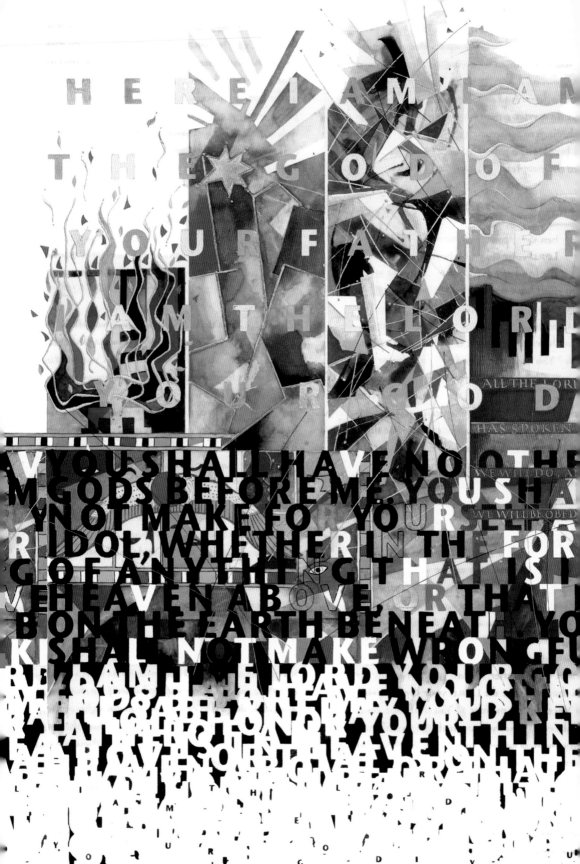

January

S	M	T	W	T	F	S	
			1	2	3	4	5
6	7	8	9	10	11	12	
13	14	15	16	17	18	19	
20	21	22	23	24	25	26	
27	28	29	30	31			

January

Monday
7

Tuesday
8

Wednesday
9

Thursday
10

Friday
11

Saturday
12

Sunday
13

EXODUS 20:1-26

Then God spoke all these words… (20:1)

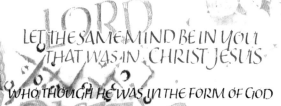

LET THE SAME MIND BE IN YOU
THAT WAS IN CHRIST JESUS

WHO THOUGH HE WAS IN THE FORM OF GOD

DID NOT REGARD

EQUALITY WITH GOD

AS SOMETHING TO BE EXPLOITED

BUT EMPTIED HIMSELF,

TAKING THE FORM OF A SLAVE,

BEING BORN IN HUMAN LIKENESS.

AND BEING FOUND IN HUMAN FORM,

HE HUMBLED HIMSELF

AND BECAME OBEDIENT TO THE POINT OF DEATH

EVEN DEATH ON A CROSS.

THEREFORE GOD ALSO HIGHLY EXALTED HIM

AND GAVE HIM THE NAME

THAT IS ABOVE EVERY NAME

SO THAT AT THE NAME OF JESUS

EVERY KNEE SHOULD BEND

IN HEAVEN AND ON EARTH

AND UNDER THE EARTH

AND EVERY TONGUE SHOULD CONFESS

THAT JESUS CHRIST
IS LORD

TO THE GLORY OF GOD THE FATHER.

January

S	M	T	W	T	F	S
		1	2	3	4	5
6	7	8	9	10	11	12
13	14	15	16	17	18	19
20	21	22	23	24	25	26
27	28	29	30	31		

January

Monday
14

Tuesday
15

Wednesday
16

Thursday
17

Friday
18

Saturday
19

Sunday
20

PHILIPPIANS 2

So that at the name of Jesus every knee should bend, in heaven and on earth and under the earth, and every tongue should confess that Jesus Christ is Lord, to the glory of God the Father. (2:10–11)

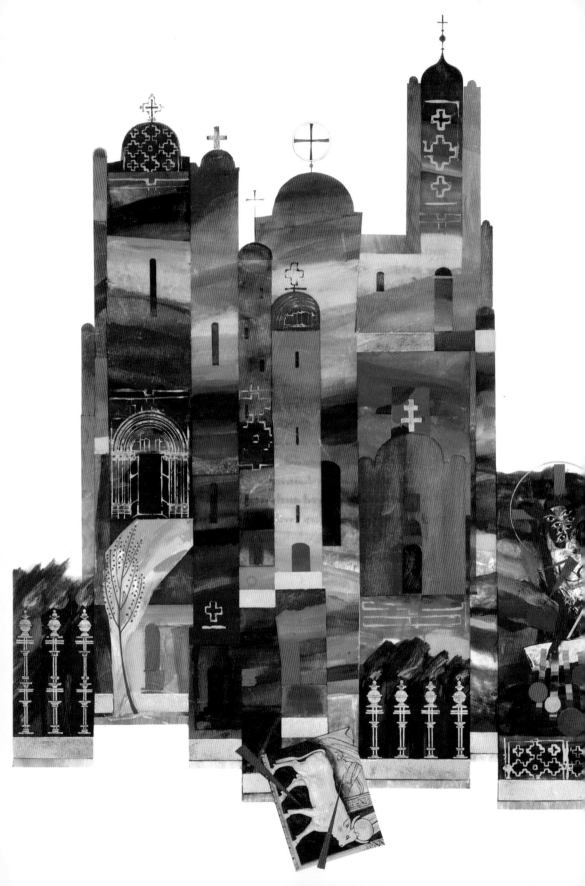

January

S	M	T	W	T	F	S	
			1	2	3	4	5
6	7	8	9	10	11	12	
13	14	15	16	17	18	19	
20	21	22	23	24	25	26	
27	28	29	30	31			

January

Martin Luther King Jr.'s Birthday (observed) (USA)

Monday
21

Tuesday
22

Wednesday
23

Thursday
24

Friday
25

Australia Day

Saturday
26

Sunday
27

REVELATION 5-6

Then I heard every creature in heaven and on earth and under the earth and in the sea, and all that is in them, singing, "To the one seated on the throne and to the Lamb be blessing and honor and glory and might for ever and ever!" (5:13)

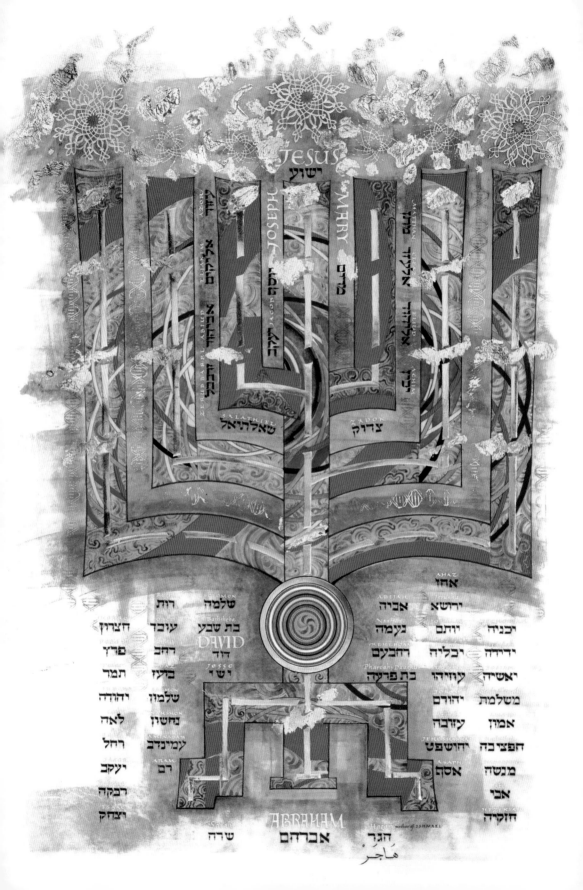

January

S	M	T	W	T	F	S
		1	2	3	4	5
6	7	8	9	10	11	12
13	14	15	16	17	18	19
20	21	22	23	24	25	26
27	28	29	30	31		

February

S	M	T	W	T	F	S
					1	2
3	4	5	6	7	8	9
10	11	12	13	14	15	16
17	18	19	20	21	22	23
24	25	26	27	28		

Australia Day (observed) (Australia—except NSW)

Monday
28

Tuesday
29

Wednesday
30

Thursday
31

Friday
1

Saturday
2

Sunday
3

MATTHEW 1:1-17

So all the generations from Abraham to David are fourteen generations; and from David to the deportation to Babylon, fourteen generations; and from the deportation to Babylon to the Messiah, fourteen generations. (1:17)

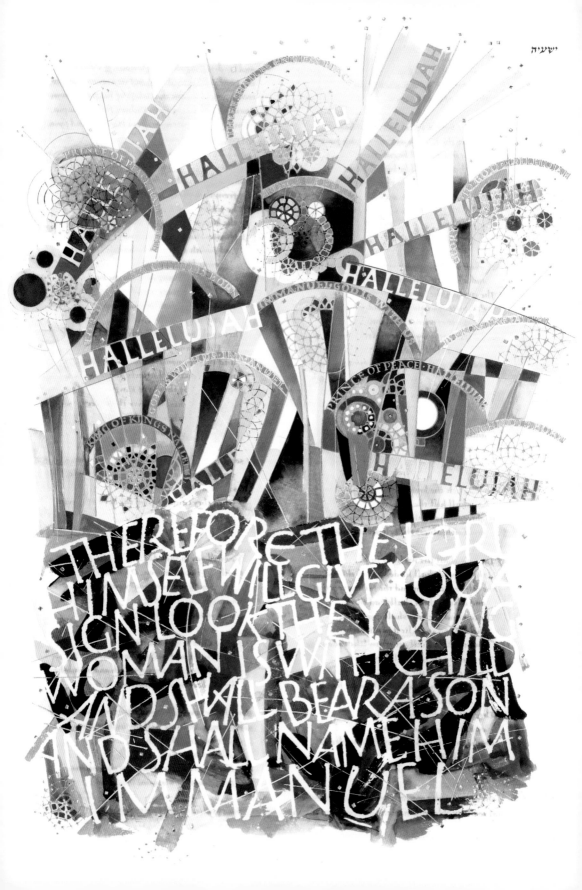

February

S	M	T	W	T	F	S
					1	2
3	4	5	6	7	8	9
10	11	12	13	14	15	16
17	18	19	20	21	22	23
24	25	26	27	28		

February

Monday
4

Tuesday
5

Waitangi Day (NZ)

Wednesday
6

Thursday
7

Friday
8

Saturday
9

Sunday
10

ISAIAH 7:13-17

Therefore the Lord himself will give you a sign. Look, the young woman is with child and shall bear a son, and shall name him Immanuel. (7:14)

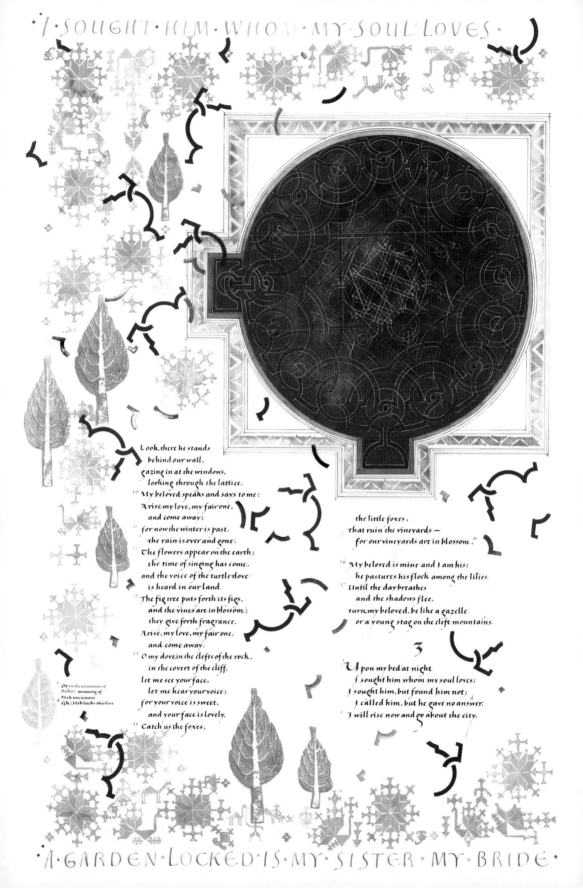

Look, there he stands
 behind our wall,
gazing in at the windows,
 looking through the lattice.
¹⁰ My beloved speaks and says to me:
 Arise, my love, my fair one,
 and come away;
¹¹ for now the winter is past,
 the rain is over and gone;
¹² The flowers appear on the earth;
 the time of singing has come,
 and the voice of the turtledove
 is heard in our land.
¹³ The fig tree puts forth its figs,
 and the vines are in blossom;
 they give forth fragrance.
 Arise, my love, my fair one,
 and come away.
¹⁴ O my dove, in the clefts of the rock,
 in the covert of the cliff,
 let me see your face,
 let me hear your voice;
 for your voice is sweet,
 and your face is lovely.
¹⁵ Catch us the foxes,

*Or on the mountains of
Bether: meaning of
Heb uncertain
ᵇ Gk: Heb lacks this line*

the little foxes,
that ruin the vineyards —
 for our vineyards are in blossom."

¹⁶ My beloved is mine and I am his;
 he pastures his flock among the lilies.
¹⁷ Until the day breathes
 and the shadows flee,
 turn, my beloved, be like a gazelle
 or a young stag on the cleft mountains.

3

Upon my bed at night
 I sought him whom my soul loves;
 I sought him, but found him not;
 I called him, but he gave no answer.ᵈ
 I will rise now and go about the city,

February

S M T W T F S
 1 2
3 4 5 6 7 8 9
10 11 12 13 14 15 16
17 18 19 20 21 22 23
24 25 26 27 28

February

Monday
11

Tuesday
12

Ash Wednesday

Wednesday
13

St. Valentine's Day

Thursday
14

Friday
15

Saturday
16

Sunday
17

SONG OF SOLOMON 3-4

…how much better is your love than wine, and the fragrance of your oils than any spice! (4:10)

LOVE IS PATIENT,
LOVE IS KIND, LOVE
IS NOT ENVIOUS OR
BOASTFUL OR ARROGANT
OR RUDE. IT DOES NOT
INSIST ON ITS OWN WAY;
IT IS NOT IRRITABLE OR RE-
SENTFUL; IT DOES NOT REJOICE
IN WRONGDOING, BUT RE-
JOICES IN THE TRUTH. IT
BEARS ALL THINGS, BELIEVES
ALL THINGS, HOPES ALL THINGS,
ENDURES ALL THINGS. LOVE
NEVER ENDS. BUT AS FOR
PROPHECIES, THEY WILL COME
TO AN END; AS FOR TONGUES,
THEY WILL CEASE; AS FOR KNOW
LEDGE, IT WILL COME TO AN END.
FOR WE KNOW ONLY IN PART
AND WE PROPHESY ONLY IN PART;
BUT WHEN THE COMPLETE COMES,
THE PARTIAL WILL COME TO AN
END. WHEN I WAS A CHILD, I
SPOKE LIKE A CHILD, I THOUGHT
LIKE A CHILD, I REASONED LIKE
A CHILD; WHEN I BECAME AN
ADULT, I PUT AN END TO CHILD-
ISH WAYS. FOR NOW WE SEE
IN A MIRROR, DIMLY, BUT THEN
WE WILL SEE FACE TO FACE. NOW
I KNOW ONLY IN PART; THEN
I WILL KNOW FULLY, EVEN AS I
HAVE BEEN FULLY KNOWN.
AND NOW FAITH, HOPE, AND
LOVE ABIDE, THESE THREE; AND
THE GREATEST OF THESE IS LOVE.

February

S	M	T	W	T	F	S
					1	2
3	4	5	6	7	8	9
10	11	12	13	14	15	16
17	18	19	20	21	22	23
24	25	26	27	28		

February

*Begins at sundown the previous day

Presidents' Day (USA)

Monday
18

Tuesday
19

Wednesday
20

Thursday
21

Friday
22

Saturday
23

Purim*

Sunday
24

1 CORINTHIANS 13

And now faith, hope, and love abide, these three; and the greatest of these is love. (13:13)

HOLY, HOLY, HOLY, THE LORD GOD THE ALMIGHTY, WHO WAS AND IS AND IS TO COME.

ΑΓΙΟΣ ΑΓΙΟΣ ΑΓΙΟΣ

SANCTVS SANCTVS SANCTVS

February

S	M	T	W	T	F	S
					1	2
3	4	5	6	7	8	9
10	11	12	13	14	15	16
17	18	19	20	21	22	23
24	25	26	27	28		

March

S	M	T	W	T	F	S
					1	2
3	4	5	6	7	8	9
10	11	12	13	14	15	16
17	18	19	20	21	22	23
24	25	26	27	28	29	30
31						

Feb-March

Monday
25

Tuesday
26

Wednesday
27

Thursday
28

St. David's Day (UK)

Friday
1

Saturday
2

Sunday
3

REVELATION 4

"You are worthy, our Lord and God, to receive glory and honor and power, for you created all things, and by your will they existed and were created." (4:11)

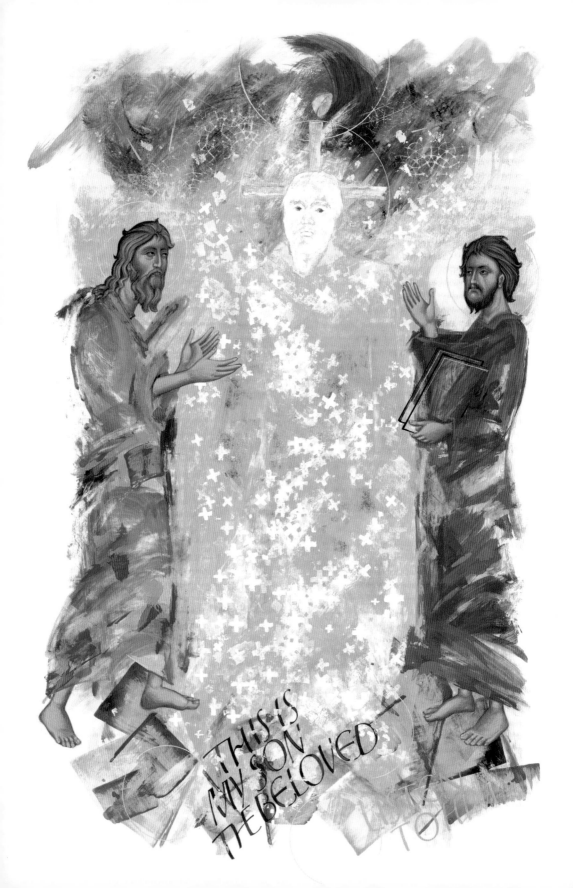

March

S	M	T	W	T	F	S
					1	2
3	4	5	6	7	8	9
10	11	12	13	14	15	16
17	18	19	20	21	22	23
24	25	26	27	28	29	30
31						

March

Labour Day (Australia—WA)

Monday
4

Tuesday
5

Wednesday
6

Thursday
7

International Women's Day

Friday
8

Saturday
9

Mothering Sunday (Ireland, UK)

Sunday
10

MARK 9:2-12

Then a cloud overshadowed them, and from the cloud there came a voice, "This is my Son, the Beloved; listen to him!" (9:7)

other side of the sea for us, and get it for us so that we may hear it & observe it?" [14] No, the word is very near to you; it is in your mouth and in your heart for you to observe. ❡ [15] See, I have set before you today life and prosperity, death & adversity. [16] If you obey the commandments of the LORD your God that I am commanding you today, by loving the LORD your God, walking in his ways, and observing his commandments, decrees, and ordinances, then you shall live & become numerous, and the LORD your God will bless you in the land that you are entering to possess. [17] But if your heart turns away and you do not hear, but are led astray to bow down to other gods & serve them, [18] I declare to you today that you shall perish; you shall not live long in the land that you are crossing the Jordan to enter and possess. [19] I call heaven and earth to witness against you today that I have set before you life and death, blessings & curses. Choose life so that you & your descendants may live, [20] loving the LORD your God, obeying him, and holding fast to him; for that means life to you and length of days, so that you may live in the land that the LORD swore to give to your ancestors, to Abraham, to Isaac, and to Jacob.

31

When Moses had finished speaking all these words to all Israel, [1] he said to them: "I am now one hundred twenty years old. I am no longer able to get about, and the LORD has told me, 'You shall not cross over this Jordan.' [3] The LORD your God himself will cross over before you. He will destroy these nations before you, and you shall dispossess them. Joshua also will cross over before you, as the LORD promised. [4] The LORD will do to them as he did to Sihon & Og, the kings of the Amorites, and to their land, when he destroyed them. [5] The LORD will give them over to you and you shall deal with them in full accord with the command that I have given to you. [6] Be strong and bold; have no fear or dread of them, because it is the LORD your God who goes with you; he will not fail you or forsake you." ❡ [7] Then Moses summoned Joshua and said to him in the sight of all Israel: "Be strong and bold, for you are the one who will go with this people into the land that the LORD has sworn to their ancestors to give them; and you will put them in possession of it. [8] It is the LORD who goes before you. He will be with you; he will not fail you or forsake you. Do not fear or be dismayed." ❡ [9] Then Moses wrote down this law, and gave it to the priests, the sons of Levi, who carried the ark of the covenant

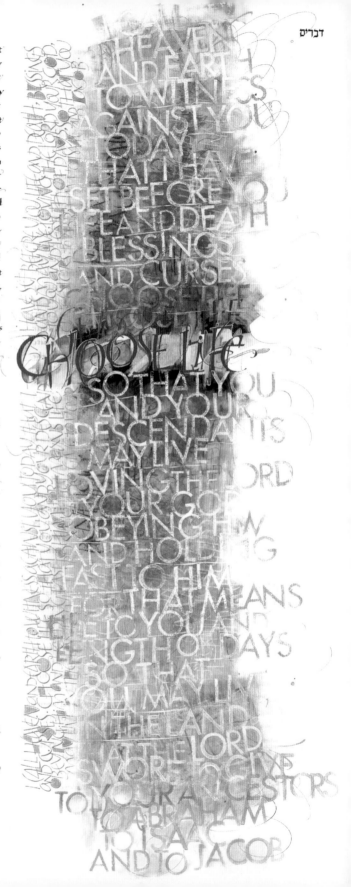

March

S	M	T	W	T	F	S
					1	2
3	4	5	6	7	8	9
10	11	12	13	14	15	16
17	18	19	20	21	22	23
24	25	26	27	28	29	30
31						

March

Eight Hours Day (Australia—TAS)

Canberra Day (Australia—ACT)

Labour Day (Australia—VIC)

Commonwealth Day (Australia, Canada, NZ, UK)

Monday
11

Tuesday
12

Wednesday
13

Thursday
14

Friday
15

Saturday
16

St. Patrick's Day

Sunday
17

DEUTERONOMY 30:19-20

I call heaven and earth to witness against you today that I have set before you life and death, blessings and curses. Choose life so that you and your descendants may live. (30:19)

Our Father in heaven,
hallowed be your name.
Your kingdom come.
Your will be done.
on earth as it is in heaven.
Give us this day our daily bread.
And forgive us our debts,
as we also have forgiven
our debtors.
And do not bring us
to the time of trial,
but rescue us from the evil one.

March

S	M	T	W	T	F	S
					1	2
3	4	5	6	7	8	9
10	11	12	13	14	15	16
17	18	19	20	21	22	23
24	25	26	27	28	29	30
31						

March

Monday
18

Tuesday
19

Wednesday
20

Thursday
21

Friday
22

Saturday
23

Palm Sunday

Sunday
24

MATTHEW 6:9-13

"Pray then in this way: Our Father in heaven, hallowed be your name." (6:9)

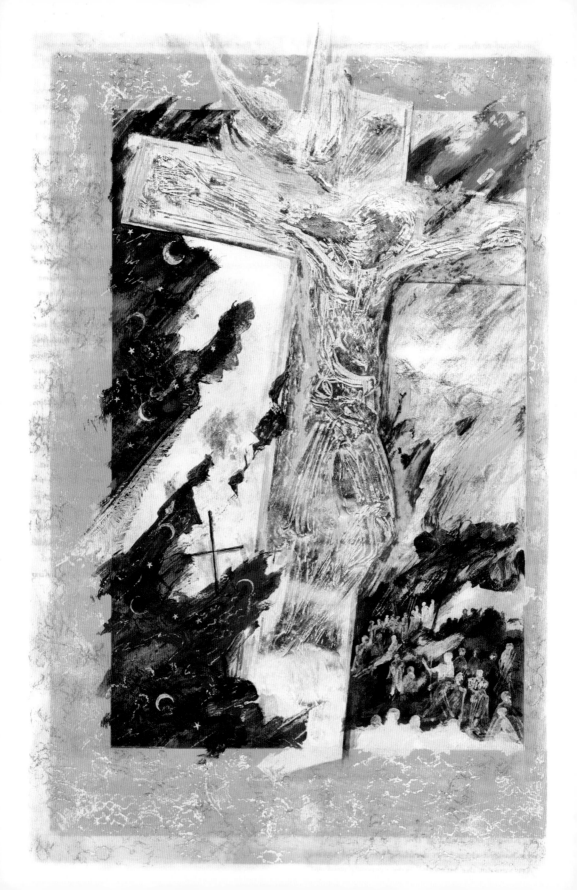

March

S M T W T F S
					1	2
3	4	5	6	7	8	9
10	11	12	13	14	15	16
17	18	19	20	21	22	23
24	25	26	27	28	29	30
31						

March

*Begins at sundown the previous day

Monday
25

Passover*

Tuesday
26

Wednesday
27

Thursday
28

Good Friday (Western)

Friday
29

Easter Saturday (Australia— except TAS, WA)

Saturday
30

Easter (Western)

Sunday
31

LUKE 23:26-49

It was now about noon, and darkness came over the whole land until three in the afternoon, while the sun's light failed; and the curtain of the temple was torn in two. (23:44-45)

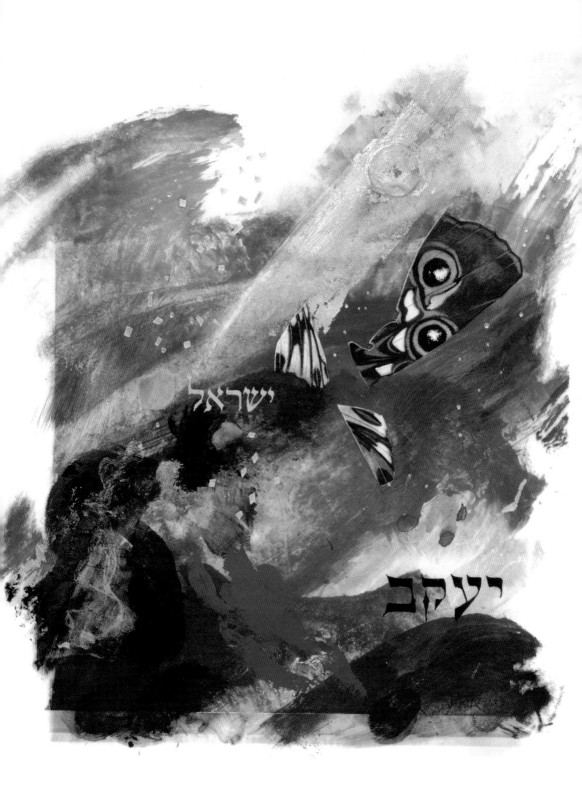

April

S M T W T F S
 1 2 3 4 5 6
7 8 9 10 11 12 13
14 15 16 17 18 19 20
21 22 23 24 25 26 27
28 29 30

April

Easter Monday (Australia, Canada, Ireland, NZ, UK—except Scotland)

Monday
1

Passover ends

Tuesday
2

Wednesday
3

Thursday
4

Friday
5

Saturday
6

Sunday
7

GENESIS 32:24-32

Jacob was left alone; and a man wrestled with him until daybreak. (32:24)

know me, [15] just as the Father knows me & I know the Father. And I lay down my life for the sheep. [16] I have other sheep that do not belong to this fold. I must bring them also, and they will listen to my voice. So there will be one flock, one shepherd. [17] For this reason the Father loves me, because I lay down my life in order to take it up again. [18] No one takes it from me, but I lay it down of my own accord. I have power to lay it down, and I have power to take it up again. I have received this command from my

19 Father." Again the Jews were divided because of these words. [20] Many of them were saying, "He has a demon & is out of his mind. Why listen to him?" [21] Others were saying, "These are not the words of one who has a demon. Can a demon open the eyes

22 of the blind?" At that time the festival of the Dedication took place in Jerusalem. It was winter, [23] and Jesus was walking in the temple, in the portico of Solomon. [24] So the Jews gathered around him and said to him, "How long will you keep us in suspense? If you are the Messiah, tell us plainly." [25] Jesus answered, "I have told you, and you do not believe. The works that I do in my Father's name testify to me; [26] but you do not believe, because you do not belong to my sheep. [27] My sheep hear my voice. I know them, and they follow me. [28] I give them eternal life, and they will never perish. No one will snatch them out of my hand. [29] What my Father has given me is greater than all else, and no one can snatch it out of the Father's hand. [30] The Father and I are one."

31 The Jews took up stones again to stone him. [32] Jesus replied, "I have shown you many good works from the Father. For which of these are you going to stone me?" [33] The Jews answered, "It is not for a good work

my Father, then do not believe me. [38] But if I do them, even though you do not believe me, believe the works, so that you may know and understand that the Father is in me & I am in the Father." [39] Then they tried to arrest him again, but he escaped from their

40 hands. He went away again across the Jordan to the place where John had been baptizing earlier, and he remained there. [41] Many came to him, and they were saying, "John performed no sign, but everything that John said about this man was true." [42] And many believed in him there.

11

Now a certain man was ill, Lazarus of Bethany, the village of Mary and her sister Martha. [2] Mary was the one who anointed the Lord with perfume and wiped his feet with her hair; her brother Lazarus was ill. [3] So the sisters sent a message to Jesus, "Lord, he whom you love is ill." [4] But when Jesus heard it, he said, "This illness does not lead to death; rather it is for God's glory, so that the Son of God may be glorified through

I AM THE RESURRECTION AND THE LIFE

April

S	M	T	W	T	F	S
	1	2	3	4	5	6
7	8	9	10	11	12	13
14	15	16	17	18	19	20
21	22	23	24	25	26	27
28	29	30				

April

Monday
8

Tuesday
9

Wednesday
10

Thursday
11

Friday
12

Saturday
13

Sunday
14

JOHN 11:1-57

When he had said this, he cried with a loud voice, "Lazarus, come out!" (11:43)

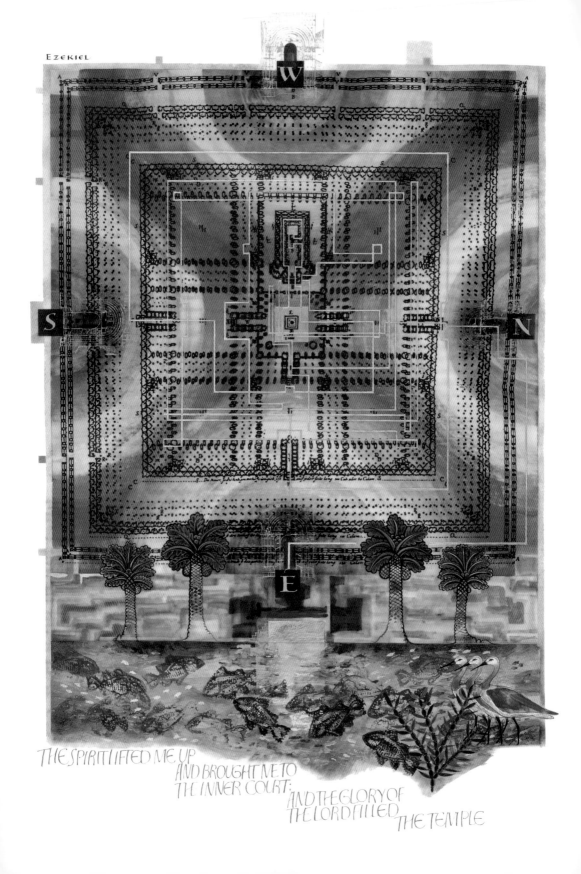

EZEKIEL

W

S

N

E

THE SPIRIT LIFTED ME UP
AND BROUGHT ME TO
THE INNER COURT:
AND THE GLORY OF
THE LORD FILLED
THE TEMPLE

April

S	M	T	W	T	F	S	
		1	2	3	4	5	6
7	8	9	10	11	12	13	
14	15	16	17	18	19	20	
21	22	23	24	25	26	27	
28	29	30					

April

Monday
15

Tuesday
16

Wednesday
17

Thursday
18

Friday
19

Saturday
20

Sunday
21

EZEKIEL 42:15-43:27

As the glory of the Lord entered the temple by the gate facing east, the spirit lifted me up, and brought me into the inner court; and the glory of the Lord filled the temple. (43:4-5)

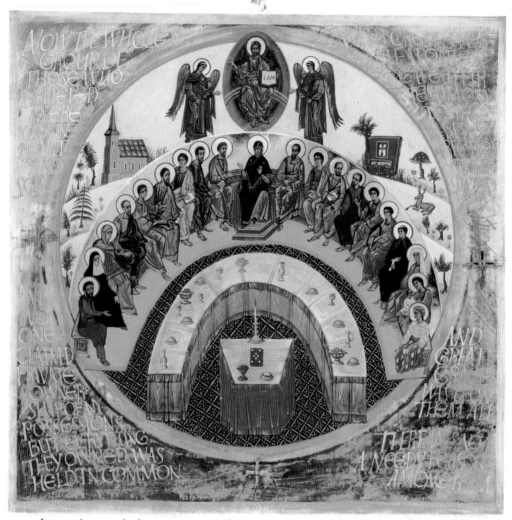

and you are determined to bring this man's blood on us." ²⁹ But Peter and the apostles answered, "We must obey God rather than any human authority. ³⁰ The God of our ancestors raised up Jesus, whom you had killed by hanging him on a tree. ³¹ God exalted him at his right hand as Leader & Savior that he might give repentance to Israel and forgiveness of sins. ³² And we are witnesses to these things and so is the Holy Spirit whom God has given to those who obey him." ■ When they heard this, they were enraged & wanted to kill them. ³⁴ But a Pharisee in the council named Gamaliel, a teacher of the law, respected by all the people, stood up and ordered the men to be put outside for a short time. ³⁵ Then he said to them, "Fellow Israelites, consider carefully what you propose to do to these men. ³⁶ For some time ago Theudas rose up, claiming to be somebody, and a number of men, about four hundred, joined him; but he was killed, and all who followed him were dispersed and disappeared. ³⁷ After him Judas the Galilean rose up at the time of the census and got people to follow him; he also perished, and

all who followed him were scattered. ³⁸ So in the present case, I tell you, keep away from these men and let them alone; because if this plan or this undertaking is of human origin, it will fail; ³⁹ but if it is of God, you will not be able to overthrow them in that case you may even be found fighting against God!" ■ They were convinced by him, ⁴⁰ and when they had called in the apostles, they had them flogged. Then they ordered them not to speak in the name of Jesus, and let them go. ⁴¹ As they left the council, they rejoiced that they were considered worthy to suffer dishonor for the sake of the name. ⁴² And every day in the temple and at home they did not cease to teach and proclaim Jesus as the Messiah.

6

Now during those days, when the disciples were increasing in number, the Hellenists complained against the Hebrews because their widows were being neglected in the daily distribution of food. ² And the twelve called together

April

S	M	T	W	T	F	S
	1	2	3	4	5	6
7	8	9	10	11	12	13
14	15	16	17	18	19	20
21	22	23	24	25	26	27
28	29	30				

Earth Day

Monday
22

St. George's Day (UK)

Tuesday
23

Wednesday
24

Anzac Day (NZ, Australia)

Thursday
25

Friday
26

Saturday
27

Sunday
28

ACTS 4:32-35

Now the whole group of those who believed were of one heart and soul, and no one claimed private ownership of any possessions, but everything they owned was held in common. (4:32)

turning aside to the right hand or to the left until 18 we passed through your territory." But Edom said to him, "You shall not pass through, or we will come out with the sword against you." 19 The Israelites said to him, "We will stay on the highway; and if we drink of your water, we and our livestock, then we will pay for it. It is only a small matter; just let us pass through on foot." 20 But he said, "You shall not pass through." And Edom came out against them with a large force, heavily armed. 21 Thus Edom refused to give Israel passage through their territory; 22 so Israel turned away from them. They set out from Kadesh, and the Israelites, the whole congregation, came to Mount Hor. 23 Then the LORD said to Moses and Aaron at Mount Hor, on the border of the land of Edom, 24 "Let Aaron be gathered to his people. For he shall not enter the land that I have given to the Israelites, because you rebelled against my command at the waters of Meribah. 25 Take Aaron & his son Eleazar, and bring them up Mount Hor; 26 strip Aaron of his vestments, and put them on his son Eleazar. But Aaron shall be gathered to his people, and shall die there." 27 Moses did as the LORD had commanded; they went up Mount Hor in the sight of the whole congregation. 28 Moses stripped Aaron of his vestments, and put them on his son Eleazar; and Aaron died there on the top of the mountain. Moses and Eleazar came down from the mountain. 29 When all the congregation saw that Aaron had died, all the house of Israel mourned for Aaron thirty days.

When the Canaanite, the king of Arad, who lived in the Negeb, heard that Israel was coming by the way of Atharim, he fought against Israel & took some of them captive. 2 Then Israel made a vow to the LORD & said, "If you will indeed give this people into our hands, then we will utterly destroy their towns." 3 The LORD listened to the voice of Israel, and handed over the Canaanites; and they utterly destroyed them and their towns; so the place was called Hormah. From Mount Hor they set out by the way to the Red Sea, to go around the land of Edom; but the people became impatient on the way. 5 The people spoke against God & against Moses, "Why have you brought us up out of Egypt to die in the wilderness? For there is no food and no water, and we detest this miserable food." 6 Then the LORD sent poisonous serpents among the people, and they bit the people, so that many Israelites died. 7 The people came to Moses & said, "We have sinned by speaking against the LORD and against you; pray to the LORD to take away the serpents from us." So

MAKE A POISONOUS SERPENT AND SET IT ON A POLE

AND EVERYONE WHO IS BITTEN SHALL LOOK AT IT AND LIVE

Moses prayed for the people. 8 And the LORD said to Moses, "Make a poisonous serpent, and set it on a pole; and everyone who is bitten shall look at it & live." 9 So Moses made a serpent of bronze, and put it upon a pole; and whenever a serpent bit someone, that person would look at the serpent of bronze & 10 live. The Israelites set out, and camped in Oboth. 11 They set out from Oboth, and camped at Iye-abarim, in the wilderness bordering Moab toward the sunrise. 12 From there they set out, and camped in the Wadi Zered. 13 From there they set out, and camped on the other side of the Arnon, in the wilderness

April

S	M	T	W	T	F	S
	1	2	3	4	5	6
7	8	9	10	11	12	13
14	15	16	17	18	19	20
21	22	23	24	25	26	27
28	29	30				

May

S	M	T	W	T	F	S
			1	2	3	4
5	6	7	8	9	10	11
12	13	14	15	16	17	18
19	20	21	22	23	24	25
26	27	28	29	30	31	

April-May

Monday
29

Tuesday
30

Wednesday
1

Thursday
2

Holy Friday (Orthodox)

Friday
3

Saturday
4

Easter (Orthodox)

Sunday
5

NUMBERS 21:8

And the Lord said to Moses, "Make a poisonous serpent, and set it on a pole; and everyone who is bitten shall look at it and live."

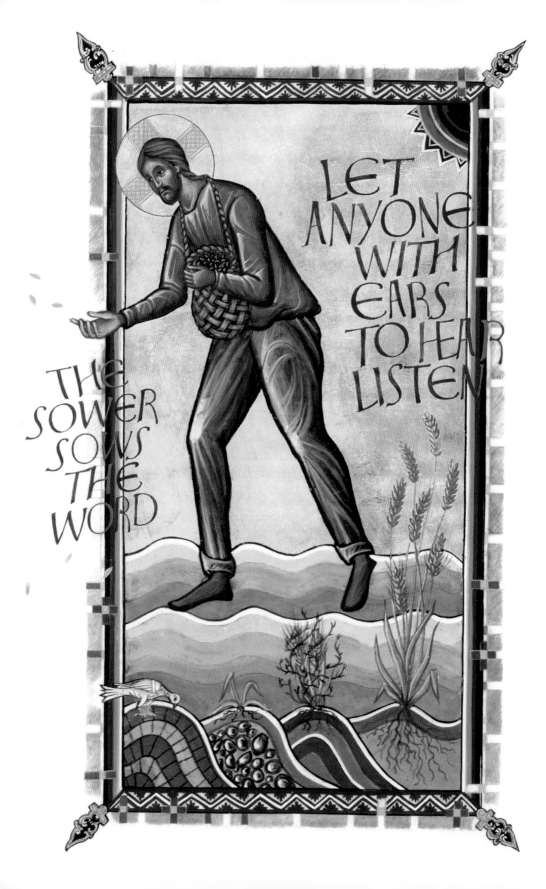

May

S	M	T	W	T	F	S
			1	2	3	4
5	6	7	8	9	10	11
12	13	14	15	16	17	18
19	20	21	22	23	24	25
26	27	28	29	30	31	

May

Labour Day (Australia—QLD)

May Day (Australia—NT)

Early May Bank Holiday (Ireland, UK)

Monday
6

Tuesday
7

Wednesday
8

Thursday
9

Friday
10

Saturday
11

Mother's Day (USA, Australia, Canada, NZ)

Sunday
12

MARK 4:2-9

He began to teach them many things in parables, and in his teaching he said to them: "Listen! A sower went out to sow. (4:2-3)

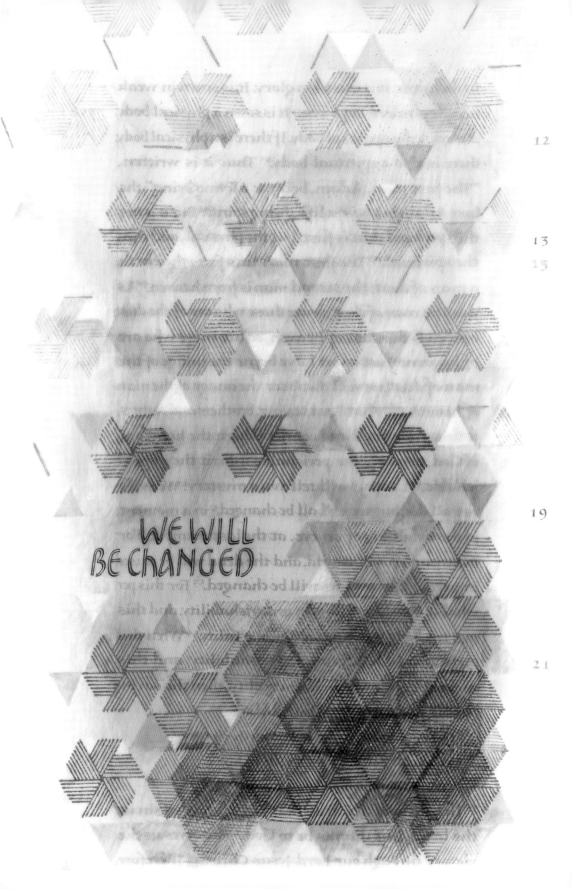

WE WILL
BE CHANGED

12

13

19

21

May

S	M	T	W	T	F	S
			1	2	3	4
5	6	7	8	9	10	11
12	13	14	15	16	17	18
19	20	21	22	23	24	25
26	27	28	29	30	31	

May

Monday
13

Tuesday
14

Wednesday
15

Thursday
16

Friday
17

Armed Forces Day (USA)

Saturday
18

Sunday
19

1 CORINTHIANS 15

Listen, I will tell you a mystery! We will not all die, but we will all be changed, in a moment, in the twinkling of an eye, at the last trumpet. For the trumpet will sound, and the dead will be raised imperishable, and we will be changed. (15:51-52)

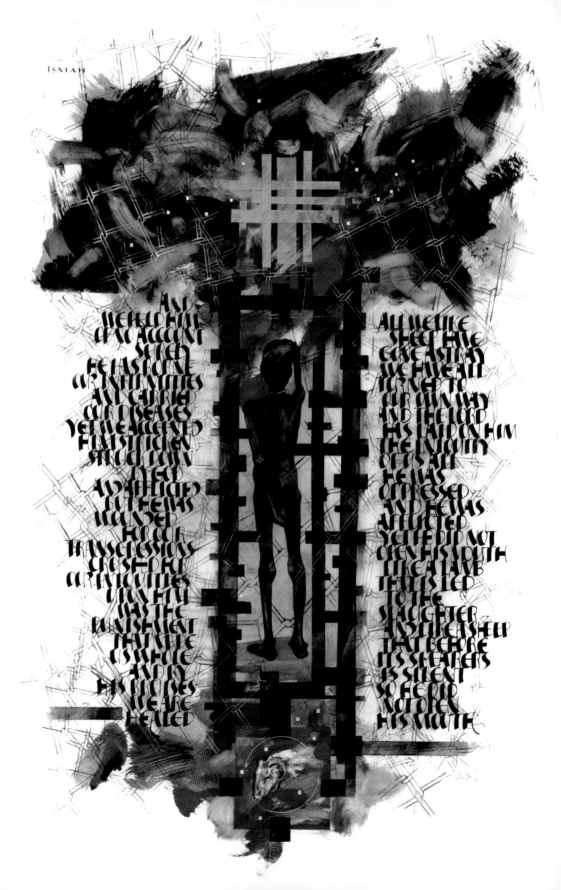

May

S	M	T	W	T	F	S
			1	2	3	4
5	6	7	8	9	10	11
12	13	14	15	16	17	18
19	20	21	22	23	24	25
26	27	28	29	30	31	

May

Victoria Day (Canada)

Monday
20

Tuesday
21

Wednesday
22

Thursday
23

Friday
24

Saturday
25

Sunday
26

ISAIAH 53:3-7

But he was wounded for our transgressions, crushed for our iniquities; upon him was the punishment that made us whole, and by his bruises we are healed. (53:5)

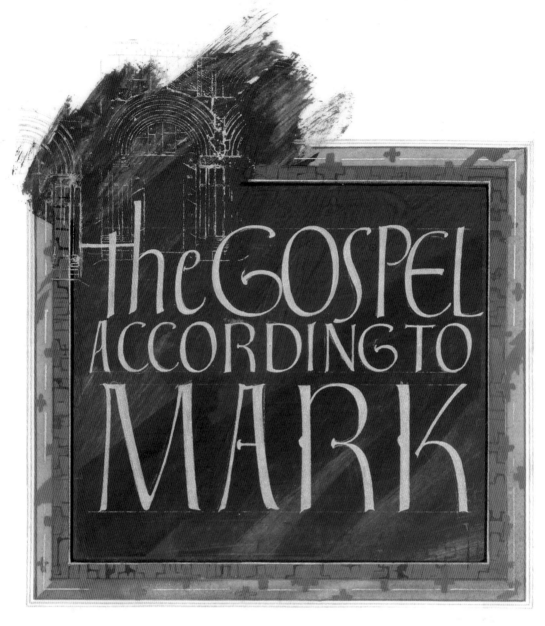

The GOSPEL ACCORDING TO MARK

THE BEGINNING OF THE GOOD NEWS [a] OF JESUS CHRIST, THE SON OF GOD. [b]

May								June						
S	M	T	W	T	F	S		S	M	T	W	T	F	S
			1	2	3	4								1
5	6	7	8	9	10	11		2	3	4	5	6	7	8
12	13	14	15	16	17	18		9	10	11	12	13	14	15
19	20	21	22	23	24	25		16	17	18	19	20	21	22
26	27	28	29	30	31			23	24	25	26	27	28	29
								30						

May-June

Memorial Day (USA)

Spring Bank Holiday (UK)

Monday
27

Tuesday
28

Wednesday
29

Thursday
30

Friday
31

Saturday
1

Sunday
2

MARK

And just as he was coming up out of the water, he saw the heavens torn apart and the Spirit descending like a dove on him. And a voice came from heaven, "You are my Son, the Beloved; with you I am well pleased." (1:10–11)

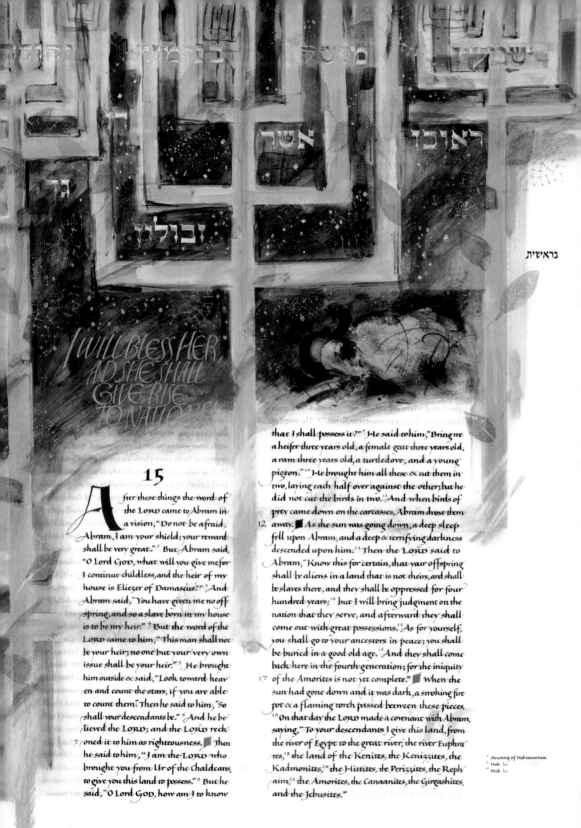

I WILL BLESS HER,
AND SHE SHALL
GIVE RISE
TO NATIONS

15

After these things the word of the LORD came to Abram in a vision, "Do not be afraid, Abram, I am your shield; your reward shall be very great." ² But Abram said, "O Lord GOD, what will you give me for I continue childless, and the heir of my house is Eliezer of Damascus?" ³ And Abram said, "You have given me no offspring, and so a slave born in my house is to be my heir." ⁴ But the word of the LORD came to him, "This man shall not be your heir; no one but your very own issue shall be your heir." ⁵ He brought him outside & said, "Look toward heaven and count the stars, if you are able to count them." Then he said to him, "So shall your descendants be." ⁶ And he believed the LORD; and the LORD reckoned it to him as righteousness. ▪ Then he said to him, "I am the LORD who brought you from Ur of the Chaldeans, to give you this land to possess." ⁸ But he said, "O Lord GOD, how am I to know that I shall possess it?" ⁹ He said to him, "Bring me a heifer three years old, a female goat three years old, a ram three years old, a turtledove, and a young pigeon." ¹⁰ He brought him all these & cut them in two, laying each half over against the other; but he did not cut the birds in two. ¹¹ And when birds of prey came down on the carcasses, Abram drove them away. ▪ ¹² As the sun was going down, a deep sleep fell upon Abram, and a deep & terrifying darkness descended upon him. ¹³ Then the LORD said to Abram, "Know this for certain, that your offspring shall be aliens in a land that is not theirs, and shall be slaves there, and they shall be oppressed for four hundred years; ¹⁴ but I will bring judgment on the nation that they serve, and afterward they shall come out with great possessions. ¹⁵ As for yourself, you shall go to your ancestors in peace; you shall be buried in a good old age. ¹⁶ And they shall come back here in the fourth generation; for the iniquity ¹⁷ of the Amorites is not yet complete." ▪ When the sun had gone down and it was dark, a smoking fire pot & a flaming torch passed between these pieces. ¹⁸ On that day the LORD made a covenant with Abram, saying, "To your descendants I give this land, from the river of Egypt to the great river, the river Euphrates, ¹⁹ the land of the Kenites, the Kenizzites, the Kadmonites, ²⁰ the Hittites, the Perizzites, the Rephaim, ²¹ the Amorites, the Canaanites, the Girgashites, and the Jebusites."

ᵍ Meaning of Heb uncertain
ʰ Heb *he*
ⁱ Heb *he*

שרה SARAH SHALL BE HER NAME

June

S	M	T	W	T	F	S
						1
2	3	4	5	6	7	8
9	10	11	12	13	14	15
16	17	18	19	20	21	22
23	24	25	26	27	28	29
30						

June

Queen's Birthday (NZ)

Foundation Day (Australia—WA)

Spring Bank Holiday (Ireland)

Monday
3

Tuesday
4

Wednesday
5

Thursday
6

Friday
7

Saturday
8

Sunday
9

GENESIS 17:1-22

"I will bless her, and moreover I will give you a son by her. I will bless her, and she shall give rise to nations; kings of peoples shall come from her." (17:16)

AND ON THIS ROCK
I WILL BUILD MY CHURCH,
AND THE GATES OF
HADES WILL NOT
PREVAIL AGAINST IT.

YOU ARE
THE
MESSIAH
THE SON
OF THE
LIVING
GOD

³⁶he took the seven loaves and the fish; and after giving thanks he broke them and gave them to the disciples, and the disciples gave them to the crowds. ³⁷And all of them ate & were filled; and they took up the broken pieces left over, seven baskets full. ³⁸Those who had eaten were four thousand men, besides women & children. ³⁹After sending away the crowds, he got into the boat and went to the region of Magadan.

יונה

16

The Pharisees and Sadducees came, and to test Jesus they asked him to show them a sign from heaven.² He answered them, "When it is evening, you say, 'It will be fair weather, for the sky is red.'³ And in the morning, 'It will be stormy today, for the sky is red and threatening.' You know how to interpret the appearance of the sky, but you cannot interpret the signs of the times.⁴An evil and adulterous generation asks for a sign,

5 but no sign will be given to it except the sign of Jonah." Then he left them and went away. When the disciples reached the other side, they had forgotten to bring any bread.⁶ Jesus said to them, "Watch out, and beware of the yeast of the Pharisees and Sadducees."⁷ They said to one another, "It is because we have brought no bread."⁸And becoming aware of it, Jesus said, "You of little faith, why are you talking about having no bread?⁹ Do you still not perceive? Do you not remember the five loaves for the five thousand, and how many baskets you gathered?¹⁰ Or the seven loaves for the four thousand, and how many baskets you gathered?¹¹How could you fail to perceive that I was not speaking about bread? Beware of the yeast of the Pharisees & Sadducees!"¹²Then they understood that he had not told them to beware of the yeast of bread, but of the teaching of the Pharisees and Sadducees.

13 Now when Jesus came into the district of Caesarea Philippi, he asked his disciples, "Who do people say that the Son of Man is?"¹⁴And they said, "Some say John the Baptist, but others Elijah, & still others Jeremiah or one of the prophets."¹⁵ He said to them, "But who do you say that I am?"¹⁶ Simon Peter answered, "You are the Messiah, the Son of the living God."¹⁷ And Jesus answered him, "Blessed are you, Simon son of Jonah! For flesh and blood has not revealed this to you, but my Father in heaven.¹⁸And I tell you, you are Peter, & on this rock I will build my church, and the gates of Hades will not prevail against it.¹⁹I will give you the keys of the kingdom of heaven, and whatever you bind on earth will be bound in heaven, and whatever you loose on earth will be loosed in heaven."²⁰ Then he sternly ordered the disciples not to tell anyone that he was the

21 Messiah. From that time on, Jesus began to show his disciples that he must go to Jerusalem & undergo great suffering at the hands of the elders and chief priests and scribes, and be killed, and on the third day be raised.²²And Peter took him aside & began to rebuke him, saying, "God forbid it, Lord! This must never happen to you."²³ But he turned and said to Peter, "Get behind me, Satan! you are a stumbling block to me; for you are setting your mind not on divine things but on human things."

24 Then Jesus told his disciples, "If any want to become my followers, let them deny themselves and take up their cross and follow me.²⁵ For those who want to save their life will lose it, & those who lose their life for my sake will find it.²⁶For what will it profit them if they gain the whole world but forfeit

† RSB
Matt 16 : 24

ᵉ Other ancient authorities read Magdala or Magdalan
ᶠ Gk: him
ᵍ Other ancient authorities lack "When it is ... of the times
ʰ Or the Christ
ⁱ Gk: Petros
ʲ Gk: petra
ᵏ Other ancient authorities add Jesus
ˡ Or the Christ

June

S	M	T	W	T	F	S
						1
2	3	4	5	6	7	8
9	10	11	12	13	14	15
16	17	18	19	20	21	22
23	24	25	26	27	28	29
30						

June

Queen's Birthday (Australia—except WA)

Monday
10

Tuesday
11

Wednesday
12

Thursday
13

Flag Day (USA)

Friday
14

Saturday
15

Father's Day (USA, Canada, Ireland, UK)

Sunday
16

MATTHEW 16:13-23

Simon Peter answered, "You are the Messiah, the Son of the living God." (16:16)

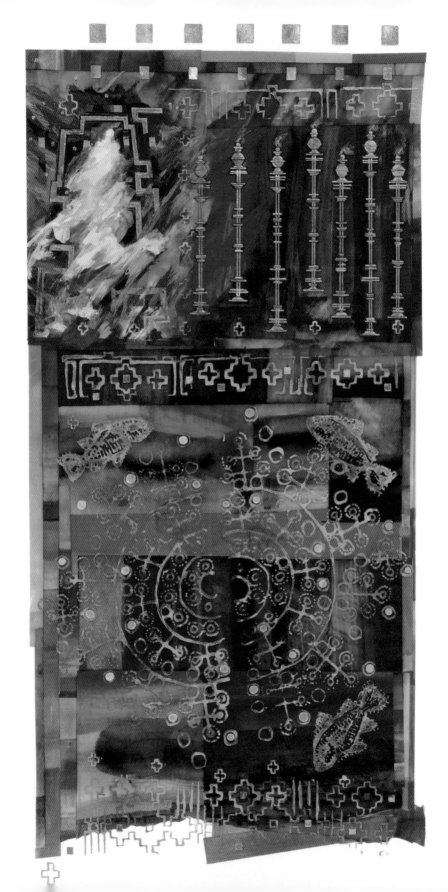

June

S M T W T F S
 1
2 3 4 5 6 7 8
9 10 11 12 13 14 15
16 17 18 19 20 21 22
23 24 25 26 27 28 29
30

June

Monday
17

Tuesday
18

Wednesday
19

Thursday
20

Friday
21

Saturday
22

Sunday
23

REVELATION 1

And in the midst of the lampstands I saw one like the Son of Man, clothed with a long robe and with a golden sash across his chest. (1:13)

"YOU SHALL LOVE THE LORD YOUR GOD WITH ALL YOUR HEART, AND WITH ALL YOUR SOUL, AND WITH ALL YOUR MIND." 38 THIS IS THE GREATEST AND FIRST COMMANDMENT. 39 AND A SECOND IS LIKE IT: "YOU SHALL LOVE YOUR NEIGHBOR AS YOURSELF." 40 ON THESE TWO COMMAND-MENTS HANG ALL THE LAW AND THE PROPHETS."

June

S M T W T F S
1
2 3 4 5 6 7 8
9 10 11 12 13 14 15
16 17 18 19 20 21 22
23 24 25 26 27 28 29
30

Monday
24

Tuesday
25

Wednesday
26

Thursday
27

Friday
28

Saturday
29

Sunday
30

LUKE 10:27

He answered, "You shall love the Lord your God with all your heart, and with all your soul, and with all your strength, and with all your mind; and your neighbor as yourself."

11 Do not ridicule a person who is
 embittered in spirit,
 for there is One who humbles and exalts.
12 Do not devise a lie against your brother,
 or do the same to a friend.
13 Refuse to utter any lie,
 for it is a habit that results in no good.
14 Do not babble in the assembly of the elders,
 and do not repeat yourself when you pray.

15 Do not hate hard labor
 or farm work, which was created by
 the Most High.
16 Do not enroll in the ranks of sinners;
 remember that retribution does not delay.
17 Humble yourself to the utmost,
 for the punishment of the ungodly
 is fire and worms.

18 Do not exchange a friend for money,
 or a real brother for the gold of Ophir.
19 Do not dismiss a wise and good wife,
 for her charm is worth more than gold.
20 Do not abuse slaves who work faithfully,
 or hired laborers who devote
 themselves to their task.
21 Let your soul love intelligent slaves;
 do not withhold from them their freedom.

22 Do you have cattle? Look after them;
 if they are profitable to you, keep them.
23 Do you have children? Discipline them,
 and make them obedient from their youth.
24 Do you have daughters? Be concerned
 for their chastity,
 and do not show yourself too
 indulgent with them.
25 Give a daughter in marriage, and you
 complete a great task;
 but give her to a sensible man.
26 Do you have a wife who pleases you?
 Do not divorce her;
 but do not trust yourself to one
 whom you detest.

27 With all your heart honor your father,
 and do not forget the birth pangs
 of your mother.
28 Remember that it was of your parents
 you were born;
 how can you repay what they
 have given to you?

Faithful friends are a sturdy shelter: whoever finds one has found a treasure. Faithful friends are beyond price: no amount can balance their worth. Faithful friends are life-saving medicine; and those who fear the Lord will find them. Those who fear the Lord direct their friendship aright, for as they are, so are their neighbors also.

My child, from your youth choose discipline, and when you have gray hair you will still find wisdom. Come to her like one who plows and sows, and wait for her good harvest. For when you cultivate her you will toil but little, and soon you will eat of her produce. She seems very harsh to the undisciplined; fools cannot remain with her. She will be like a heavy stone to test them, and they will not delay in casting her aside.

For wisdom is like her name; she is not readily perceived by many.

July

July

S	M	T	W	T	F	S
	1	2	3	4	5	6
7	8	9	10	11	12	13
14	15	16	17	18	19	20
21	22	23	24	25	26	27
28	29	30	31			

Canada Day

Monday
1

Tuesday
2

Wednesday
3

Independence Day (USA)

Thursday
4

Friday
5

Saturday
6

Sunday
7

ECCLESIASTICUS (SIRACH) 6:14-22

Faithful friends are a sturdy shelter; whoever finds one has found a treasure. (6:14)

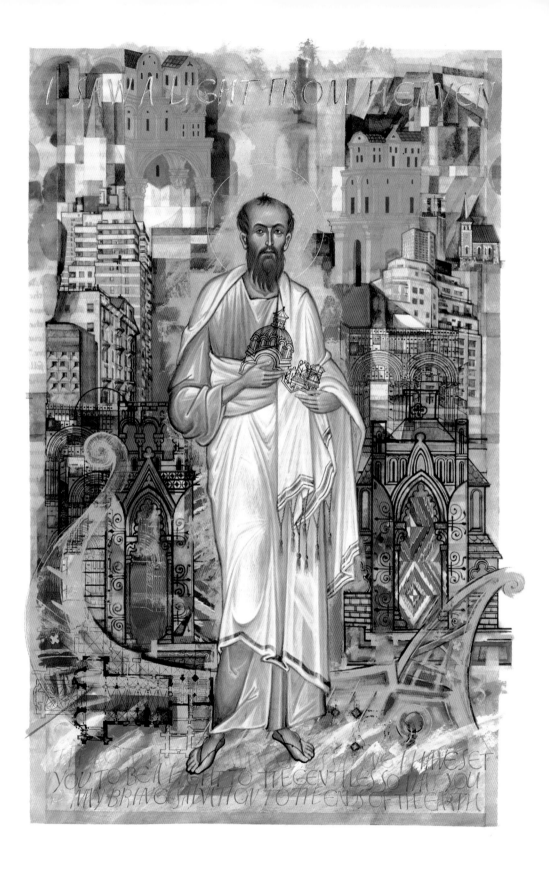

I SAW A LIGHT FROM HEAVEN

YOU TO BE A LIGHT TO THE GENTILES SO THAT YOU
MY BRING SALVATION TO THE ENDS OF THE EARTH

July

S	M	T	W	T	F	S
	1	2	3	4	5	6
7	8	9	10	11	12	13
14	15	16	17	18	19	20
21	22	23	24	25	26	27
28	29	30	31			

Monday
8

Ramadan

Tuesday
9

Wednesday
10

Thursday
11

Friday
12

Saturday
13

Sunday
14

ACTS 9:1-22; 15:1-35; 17:16-34; 22:17-21; 25-28

But the Lord said to him, "Go, for he is an instrument whom I have chosen to bring my name before Gentiles and kings and before the people of Israel." (9:15)

I HAVE LET YOU SEE IT WITH YOUR EYES BUT YOU SHALL NOT CROSS OVER THERE

THEN MOSES THE
SERVANT OF THE LORD · DIED THERE
IN THE LAND OF MOAB
AT THE LORD'S COMMAND

July

S M T W T F S
1 2 3 4 5 6
7 8 9 10 11 12 13
14 15 16 17 18 19 20
21 22 23 24 25 26 27
28 29 30 31

July

Monday
15

Tuesday
16

Wednesday
17

Thursday
18

Friday
19

Saturday
20

Sunday
21

DEUTERONOMY 34:4

The Lord said to him, "This is the land of which I swore to Abraham, to Isaac, and to Jacob, saying, 'I will give it to your descendants'; I have let you see it with your eyes, but you shall not cross over there."

I AM THE
THE GATE
I AM THE
I AM I AM
THE GATE
THE GATE
THE GATE

THE LIGHT

July

S	M	T	W	T	F	S
	1	2	3	4	5	6
7	8	9	10	11	12	13
14	15	16	17	18	19	20
21	22	23	24	25	26	27
28	29	30	31			

July

Monday
22

Tuesday
23

Wednesday
24

Thursday
25

Friday
26

Saturday
27

Sunday
28

JOHN 6:25-40; 8:12-20; 10:7-18; 14:6-14; 15:1-11

Jesus said to him, "I am the way, and the truth, and the life. No one comes to the Father except through me."
(14:6)

AND BLOSSOM LIKE A ROSE GROWING BY A STREAM OF WATER. SEND OUT FRAGRANCE LIKE INCENSE, AND PUT FORTH BLOSSOMS LIKE A LILY. SCATTER THE FRAGRANCE, AND SING A HYMN OF PRAISE; BLESS THE LORD FOR ALL HIS WORKS. ASCRIBE MAJESTY TO HIS NAME AND GIVE THANKS TO HIM WITH PRAISE, WITH SONGS ON YOUR LIPS, WITH HARPS; THIS IS WHAT YOU SHALL SAY IN THANKSGIVING:

their mother's womb
until the day they return to the
mother of all the living.

2 Perplexities and fear of heart are theirs,
and anxious thought of the day of their death.

3 From the one who sits on a splendid throne
to the one who grovels in dust and ashes,

4 from the one who wears purple and a crown
to the one who is clothed in burlap,

5 there is anger and envy and trouble and unrest,
and fear of death, and fury and strife.
And when one rests upon his bed,
his sleep at night confuses his mind.

6 He gets little or no rest;
he struggles in his sleep as he did by day.
He is troubled by the visions of his mind
like one who has escaped from the battlefield.

7 At the moment he reaches safety he wakes up,
astonished that his fears were groundless.

8 To all creatures, human and animal,
but to sinners seven times more,

9 come death and bloodshed and strife & sword,
calamities and famine and ruin and plague.

10 All these were created for the wicked,
and on their account the flood came.

11 All that is of earth returns to earth,
and what is from above returns above.

12 All bribery and injustice will be blotted out,
but good faith will last forever.

13 The wealth of the unjust will
dry up like a river,
and crash like a loud clap of
thunder in a storm.

14 As a generous person has cause to rejoice,
so lawbreakers will utterly fail.

15 The children of the ungodly
put out few branches;
they are unhealthy roots on sheer rock.

16 The reeds by any water or river bank
are plucked up before any grass;

17 but kindness is like a garden of blessings,
and almsgiving endures forever.

18 Wealth and wages make life sweet,
but better than either is finding a treasure.

19 Children and the building of a city
establish one's name,
but better than either is the one
who finds wisdom.
Cattle and orchards make one prosperous;
but a blameless wife is accounted
better than either.

20 Wine and music gladden the heart,
but the love of friends is better than either.

21 The flute and the harp make sweet melody,
but a pleasant voice is better than either.

22 The eye desires grace and beauty,
but the green shoots of grain
more than either.

23 A friend or companion is always welcome,
but a sensible wife is better than either.

24 Kindred and helpers are for a time of trouble,
but almsgiving rescues better than either.

25 Gold and silver make one stand firm,
but good counsel is esteemed
more than either.

26 Riches and strength build up confidence,
but the fear of the Lord is better than either.
There is no want in the fear of the Lord,
and with it there is no need to seek for help.

27 The fear of the Lord is like a
garden of blessing,
and covers a person better than any glory.

28 My child, do not lead the life of a beggar;
it is better to die than to beg.

Other Gk and Lat
authorities are here
d Heb: Gk: of all
r Arm: Meaning of Gk
uncertain
s Heb Syr: Gk Lat: fr
water returns to the s
t Heb: Gk: life is swee
the self-reliant work
Heb Syr: Gk lacks t
better..... prosper
v Heb: Gk: wisdom
w Heb Compare Syr
wife with her husba

	July					
S	M	T	W	T	F	S
	1	2	3	4	5	6
7	8	9	10	11	12	13
14	15	16	17	18	19	20
21	22	23	24	25	26	27
28	29	30	31			

	August						
S	M	T	W	T	F	S	
					1	2	3
4	5	6	7	8	9	10	
11	12	13	14	15	16	17	
18	19	20	21	22	23	24	
25	26	27	28	29	30	31	

July-August

Monday
29

Tuesday
30

Wednesday
31

Thursday
1

Friday
2

Saturday
3

Sunday
4

SIRACH 39:12-35

"All the works of the Lord are very good, and whatever he commands will be done at the appointed time."
(39:16)

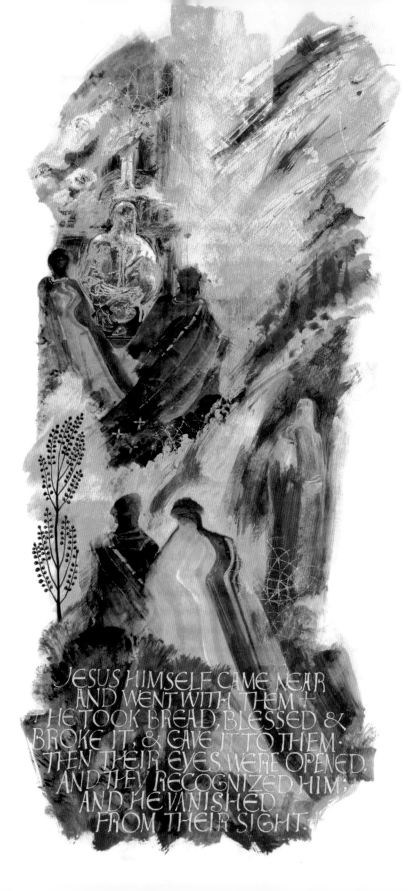

JESUS HIMSELF CAME NEAR
AND WENT WITH THEM
HE TOOK BREAD, BLESSED &
BROKE IT, & GAVE IT TO THEM:
THEN THEIR EYES WERE OPENED,
AND THEY RECOGNIZED HIM;
AND HE VANISHED
FROM THEIR SIGHT.

August

S	M	T	W	T	F	S	
					1	2	3
4	5	6	7	8	9	10	
11	12	13	14	15	16	17	
18	19	20	21	22	23	24	
25	26	27	28	29	30	31	

Summer Bank Holiday (Ireland, UK—Scotland, Australia—NSW)

Picnic Day (Australia—NT)

Monday
5

Tuesday
6

Wednesday
7

Eid al-Fitr

Thursday
8

Friday
9

Saturday
10

Sunday
11

LUKE 24:13-36

While they were talking and discussing, Jesus himself came near and went with them, but their eyes were kept from recognizing him. (24:15-16)

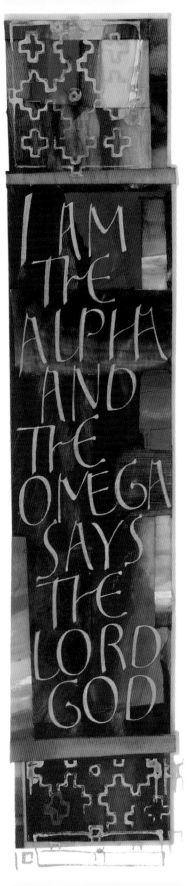

I AM THE ALPHA AND THE OMEGA SAYS THE LORD GOD

I WAS IN THE SPIRIT ON THE LORDS DAY AND I HEARD BEHIND ME A LOUD VOICE LIKE A TRUMPET SAYING WRITE IN A BOOK WHAT YOU SEE AND SEND IT TO THE SEVEN CHURCHES

August

S M T W T F S
 1 2 3
4 5 6 7 8 9 10
11 12 13 14 15 16 17
18 19 20 21 22 23 24
25 26 27 28 29 30 31

August

Monday
12

Tuesday
13

Wednesday
14

Thursday
15

Friday
16

Saturday
17

Sunday
18

REVELATION 1

"I am the Alpha and the Omega," says the Lord God, who is and who was and who is to come, the Almighty. (1:8)

IF I SPEAK
IN THE TONGUES
OF MORTALS
AND OF ANGELS,
BUT DO NOT HAVE LOVE,
I AM A NOISY GONG
OR A CLANGING
CYMBAL. AND
IF I HAVE PROPHETIC POWERS,
AND UNDERSTAND
ALL MYSTERIES
AND ALL KNOWLEDGE,
AND IF I HAVE ALL FAITH,
SO AS TO REMOVE MOUNTAINS,
BUT DO NOT HAVE LOVE,
I AM NOTHING.
IF I GIVE AWAY
ALL MY POSSESSIONS,
AND IF I HAND OVER MY BODY
SO THAT I MAY BOAST,
BUT DO NOT HAVE LOVE,
I GAIN NOTHING.

August

S	M	T	W	T	F	S
				1	2	3
4	5	6	7	8	9	10
11	12	13	14	15	16	17
18	19	20	21	22	23	24
25	26	27	28	29	30	31

August

Monday
19

Tuesday
20

Wednesday
21

Thursday
22

Friday
23

Saturday
24

Sunday
25

1 CORINTHIANS 13

And if I have prophetic powers, and understand all mysteries and all knowledge, and if I have all faith, so as to remove mountains, but do not have love, I am nothing. (13:2)

ישעיה

ISAIAH

THE VISION OF ISAIAH
SON OF AMOZ WHICH
HE SAW CONCERNING
JUDAH & JERUSALEM
IN THE DAYS OF UZZIAH
JOTHAM AHAZ & HEZE-
KIAH KINGS OF JUDAH.

August								September						
S	M	T	W	T	F	S		S	M	T	W	T	F	S
				1	2	3		1	2	3	4	5	6	7
4	5	6	7	8	9	10		8	9	10	11	12	13	14
11	12	13	14	15	16	17		15	16	17	18	19	20	21
18	19	20	21	22	23	24		22	23	24	25	26	27	28
25	26	27	28	29	30	31		29	30					

Aug-Sept

Summer Bank Holiday (UK—except Scotland)

Monday
26

Tuesday
27

Wednesday
28

Thursday
29

Friday
30

Saturday
31

Father's Day (Australia, NZ)

Sunday
1

ISAIAH

Learn to do good; seek justice, rescue the oppressed, defend the orphan, plead for the widow. (1:17)

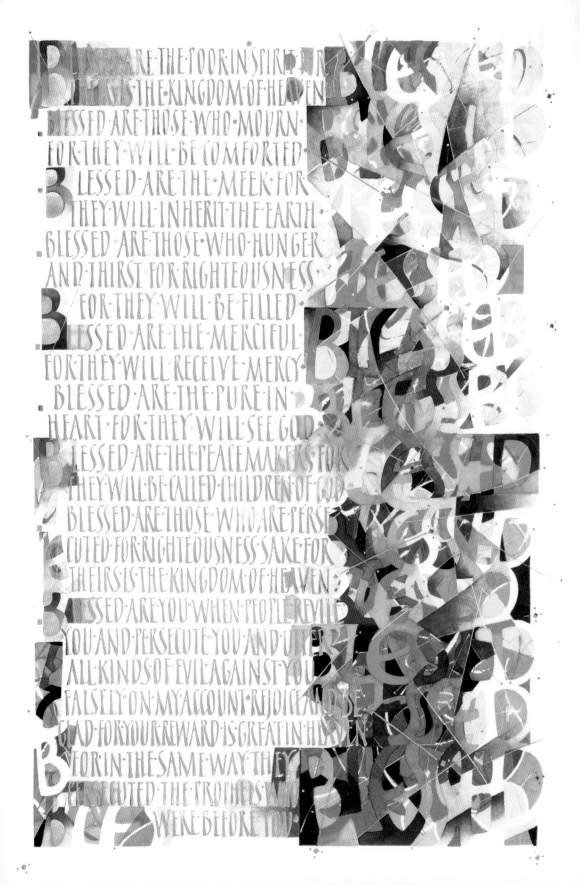

BLESSED ARE THE POOR IN SPIRIT FOR THEIRS IS THE KINGDOM OF HEAVEN. BLESSED ARE THOSE WHO MOURN FOR THEY WILL BE COMFORTED. BLESSED ARE THE MEEK FOR THEY WILL INHERIT THE EARTH. BLESSED ARE THOSE WHO HUNGER AND THIRST FOR RIGHTEOUSNESS FOR THEY WILL BE FILLED. BLESSED ARE THE MERCIFUL FOR THEY WILL RECEIVE MERCY. BLESSED ARE THE PURE IN HEART FOR THEY WILL SEE GOD. BLESSED ARE THE PEACEMAKERS FOR THEY WILL BE CALLED CHILDREN OF GOD. BLESSED ARE THOSE WHO ARE PERSECUTED FOR RIGHTEOUSNESS SAKE FOR THEIRS IS THE KINGDOM OF HEAVEN. BLESSED ARE YOU WHEN PEOPLE REVILE YOU AND PERSECUTE YOU AND UTTER ALL KINDS OF EVIL AGAINST YOU FALSELY ON MY ACCOUNT REJOICE AND BE GLAD FOR YOUR REWARD IS GREAT IN HEAVEN FOR IN THE SAME WAY THEY PERSECUTED THE PROPHETS WHO WERE BEFORE YOU.

September

S M T W T F S
1 2 3 4 5 6 7
8 9 10 11 12 13 14
15 16 17 18 19 20 21
22 23 24 25 26 27 28
29 30

September

*Begins at sundown the previous day

Labor Day (USA, Canada)

Monday
2

Tuesday
3

Wednesday
4

Rosh Hashanah*

Thursday
5

Rosh Hashanah ends

Friday
6

Saturday
7

Sunday
8

MATTHEW 5:1-12

When Jesus saw the crowds, he went up the mountain; and after he sat down, his disciples came to him.
Then he began to speak, and taught them, saying… (5:1-2)

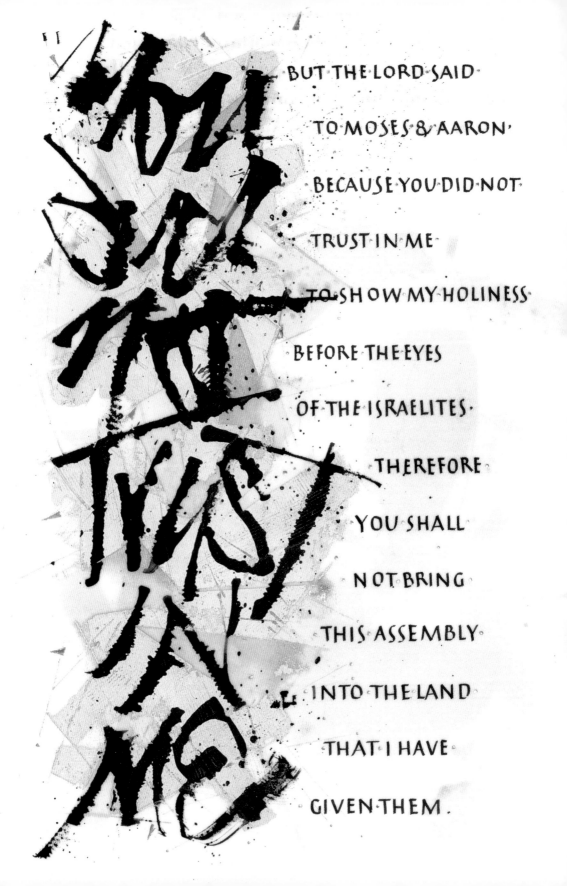

BUT THE LORD SAID · TO MOSES & AARON · BECAUSE YOU DID NOT · TRUST IN ME · TO SHOW MY HOLINESS · BEFORE THE EYES · OF THE ISRAELITES · THEREFORE · YOU SHALL · NOT BRING · THIS ASSEMBLY · INTO THE LAND · THAT I HAVE · GIVEN THEM ·

September

S M T W T F S
1 2 3 4 5 6 7
8 9 10 11 12 13 14
15 16 17 18 19 20 21
22 23 24 25 26 27 28
29 30

September

*Begins at sundown the previous day

Monday
9

Tuesday
10

Wednesday
11

Thursday
12

Friday
13

Yom Kippur*

Saturday
14

Sunday
15

NUMBERS 20:12

But the Lord said to Moses and Aaron, "Because you did not trust in me, to show my holiness before the eyes of the Israelites, therefore you shall not bring this assembly into the land that I have given them."

YOU SHALL NOT
TAKE · VENGEANCE
OR BEAR A GRUDGE
AGAINST ANY
OF YOUR · PEOPLE

BUT YOU SHALL LOVE
YOUR NEIGHBOR
AS · YOURSELF

I AM THE LORD

September

S	M	T	W	T	F	S
1	2	3	4	5	6	7
8	9	10	11	12	13	14
15	16	17	18	19	20	21
22	23	24	25	26	27	28
29	30					

September

Monday
16

Tuesday
17

Wednesday
18

Thursday
19

Friday
20

U.N. International Day of Peace

Saturday
21

Sunday
22

LEVITICUS 19:34

*The alien who resides with you shall be to you as the citizen among you; you shall love the alien as yourself,
for you were aliens in the land of Egypt: I am the Lord your God.*

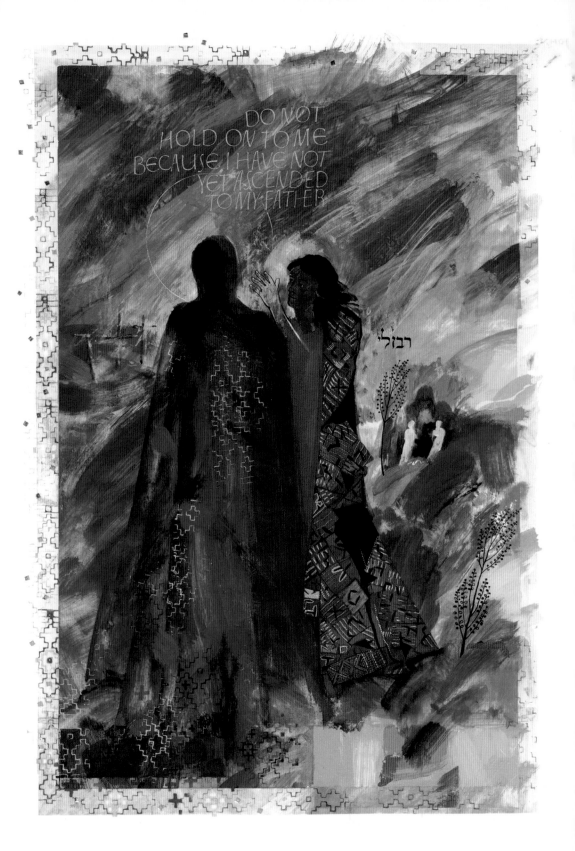

September

S	M	T	W	T	F	S
1	2	3	4	5	6	7
8	9	10	11	12	13	14
15	16	17	18	19	20	21
22	23	24	25	26	27	28
29	30					

September

Monday
23

Tuesday
24

Wednesday
25

Thursday
26

Friday
27

Saturday
28

Sunday
29

JOHN 20:1-23

Jesus said to her, "Woman, why are you weeping? Whom are you looking for?" Supposing him to be the gardener, she said to him, "Sir, if you have carried him away, tell me where you have laid him, and I will take him away." (20:15)

THIS IS THE COVENANT
THAT I WILL MAKE
WITH THE HOUSE OF ISRAEL
AFTER THOSE DAYS, SAYS THE LORD:
I WILL PUT MY LAWS
IN THEIR MINDS,
AND WRITE THEM
ON THEIR HEARTS,
AND I WILL
BE THEIR GOD,
AND THEY SHALL
BE MY PEOPLE.

September								October						
S	M	T	W	T	F	S		S	M	T	W	T	F	S
1	2	3	4	5	6	7				1	2	3	4	5
8	9	10	11	12	13	14		6	7	8	9	10	11	12
15	16	17	18	19	20	21		13	14	15	16	17	18	19
22	23	24	25	26	27	28		20	21	22	23	24	25	26
29	30							27	28	29	30	31		

Sept-Oct

Queen's Birthday (Australia—WA)

Monday
30

Tuesday
1

Wednesday
2

Thursday
3

Friday
4

Saturday
5

Sunday
6

HEBREWS 8:10

This is the covenant that I will make with the house of Israel after those days, says the Lord: I will put my laws in their minds, and write them on their hearts, and I will be their God, and they shall be my people.

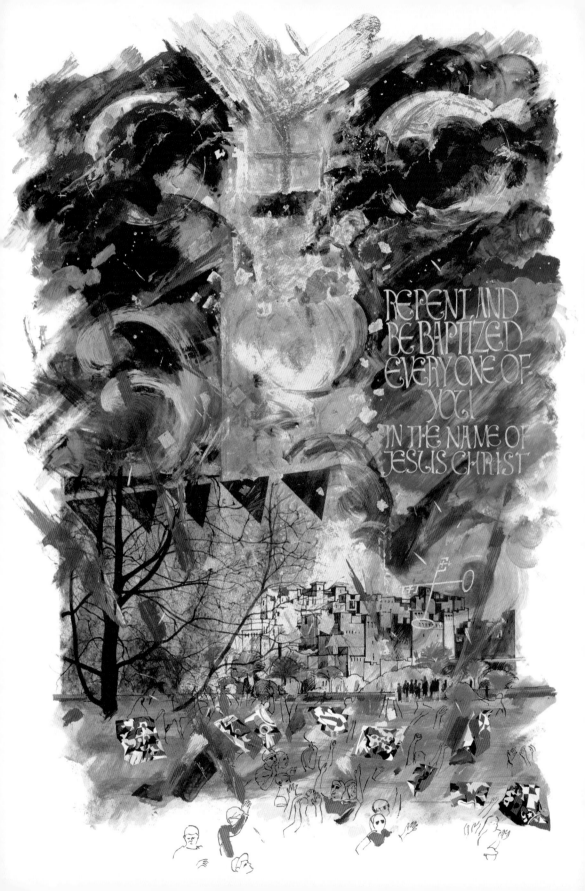

October

October

S	M	T	W	T	F	S
		1	2	3	4	5
6	7	8	9	10	11	12
13	14	15	16	17	18	19
20	21	22	23	24	25	26
27	28	29	30	31		

Labour Day (Australia—ACT, SA, NSW)

Monday
7

Tuesday
8

Wednesday
9

Thursday
10

Friday
11

Saturday
12

Sunday
13

ACTS 1:6-11; 2:1-47

And suddenly from heaven there came a sound like the rush of a violent wind, and it filled the entire house where they were sitting. (2:2)

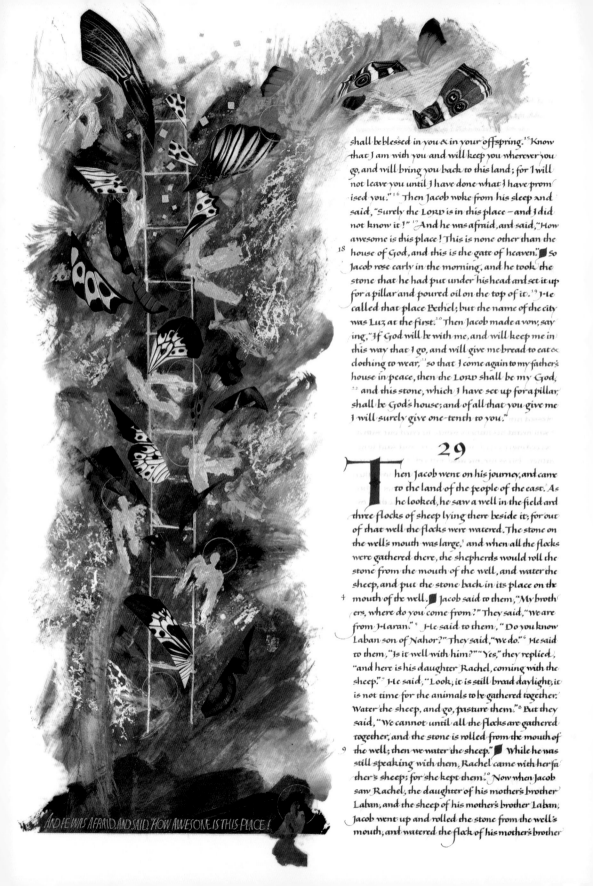

shall be blessed in you & in your offspring. [15] Know that I am with you and will keep you wherever you go, and will bring you back to this land; for I will not leave you until I have done what I have promised you." [16] Then Jacob woke from his sleep and said, "Surely the LORD is in this place — and I did not know it!" [17] And he was afraid, and said, "How awesome is this place! This is none other than the house of God, and this is the gate of heaven." [18] So Jacob rose early in the morning, and he took the stone that he had put under his head and set it up for a pillar and poured oil on the top of it. [19] He called that place Bethel; but the name of the city was Luz at the first. [20] Then Jacob made a vow, saying, "If God will be with me, and will keep me in this way that I go, and will give me bread to eat & clothing to wear, [21] so that I come again to my father's house in peace, then the LORD shall be my God, [22] and this stone, which I have set up for a pillar, shall be God's house; and of all that you give me I will surely give one-tenth to you."

29

Then Jacob went on his journey, and came to the land of the people of the east. As he looked, he saw a well in the field and three flocks of sheep lying there beside it; for out of that well the flocks were watered. The stone on the well's mouth was large, [3] and when all the flocks were gathered there, the shepherds would roll the stone from the mouth of the well, and water the sheep, and put the stone back in its place on the [4] mouth of the well. Jacob said to them, "My brothers, where do you come from?" They said, "We are from Haran." [5] He said to them, "Do you know Laban son of Nahor?" They said, "We do." [6] He said to them, "Is it well with him?" "Yes," they replied, "and here is his daughter Rachel, coming with the sheep." [7] He said, "Look, it is still broad daylight; it is not time for the animals to be gathered together. Water the sheep, and go, pasture them." [8] But they said, "We cannot until all the flocks are gathered together, and the stone is rolled from the mouth of [9] the well; then we water the sheep." While he was still speaking with them, Rachel came with her father's sheep; for she kept them. [10] Now when Jacob saw Rachel, the daughter of his mother's brother Laban, and the sheep of his mother's brother Laban, Jacob went up and rolled the stone from the well's mouth, and watered the flock of his mother's brother

AND HE WAS AFRAID, AND SAID, "HOW AWESOME IS THIS PLACE!"

October

S	M	T	W	T	F	S
		1	2	3	4	5
6	7	8	9	10	11	12
13	14	15	16	17	18	19
20	21	22	23	24	25	26
27	28	29	30	31		

October

Columbus Day (USA)

Thanksgiving (Canada)

Monday
14

Eid al-Adha

Tuesday
15

Wednesday
16

Thursday
17

Friday
18

Saturday
19

Sunday
20

GENESIS 28:10-22

And he dreamed that there was a ladder set up on the earth, the top of it reaching to heaven; and the angels of God were ascending and descending on it. (28:12)

were blind. ²²And he answered them, "Go and tell John what you have seen & heard: the blind receive their sight, the lame walk, the lepers are cleansed, the deaf hear, the dead are raised, the poor have good news brought to them. ²³And blessed is any one who takes no offense at me." ▌When John's messengers had gone, Jesus began to speak to the crowds about John: "What did you go out into the wilderness to look at? A reed shaken by the wind? ²⁵What then did you go out to see? Someone dressed in soft robes? Look, those who put on fine clothing and live in luxury are in royal palaces.²⁶What then did you go out to see? A prophet? Yes, I tell you, & more than a prophet. ²⁷This is the one about whom it is written,

'See, I am sending my messenger ahead of you,
who will prepare your way before you.'

²⁸I tell you, among those born of women no one is greater than John; yet the least in the kingdom of God is greater than he. ²⁹[And all the people who heard this, including the tax collectors, acknowledged the justice of God, because they had been baptized with John's baptism. ³⁰But by refusing to be baptized by him, the Pharisees & the lawyers rejected God's purpose for themselves.] ▌"To what then will I compare the people of this generation, and what are they like? ³²They are like children sitting in the marketplace and calling to one another:

'We played the flute for you, and you did not dance;
we wailed, and you did not weep.'

³³For John the Baptist has come eating no bread & drinking no wine, and you say, 'He has a demon'; ³⁴the Son of Man has come eating & drinking, and you say, 'Look, a glutton and a drunkard, a friend of tax collectors and sinners!' ³⁵Nevertheless, wisdom is vindicated by all her children." ▌One of the Pharisees asked Jesus to eat with him, and he went into the Pharisee's house and took his place at the table. ³⁷And a woman in the city, who was a sinner, having learned that he was eating in the Pharisee's house, brought an alabaster jar of ointment. ³⁸She

stood behind him at his feet, weeping, and began to bathe his feet with her tears and to dry them with her hair. Then she continued kissing his feet and anointing them with the ointment. ³⁹Now when the Pharisee who had invited him saw it, he said to himself, "If this man were a prophet, he would have known who and what kind of woman this is who is touching him—that she is a sinner.⁴⁰Jesus spoke up & said to him, "Simon, I have something to say to you." "Teacher," he replied, "speak." ⁴¹"A certain creditor had two debtors; one owed five hundred denarii, and the other fifty.⁴²When they could not pay, he canceled the debts for both of them. Now which of them will love him more?" ⁴³Simon answered, "I suppose the one for whom he canceled the greater debt." And Jesus said to him, "You have judged rightly. ⁴⁴Then turning toward the woman, he said to Simon, "Do you see this woman? I entered your house; you gave me no water for my feet, but she has bathed my feet with her tears & dried them with her hair. ⁴⁵You gave me no kiss, but from the time I came in she has not stopped kissing my feet. ⁴⁶You did not anoint my head with oil, but she has anointed my feet with ointment. ⁴⁷Therefore, I tell you, her sins, which were many, have been forgiven; hence she has shown great love. But the one to whom little is forgiven, loves little." ⁴⁸Then he said to her, "Your sins are forgiven." ⁴⁹But those who were at the table with him began to say among themselves, "Who is this who even forgives sins? ⁵⁰And he said to the woman, "Your faith has saved you; go in peace."

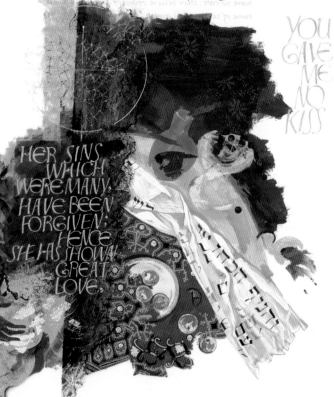

HER SINS
WHICH
WERE MANY,
HAVE BEEN
FORGIVEN;
HENCE
SHE HAS SHOWN
GREAT
LOVE.

YOU
GAVE
ME
NO
KISS

ᵃ The terms leper and leprosy can refer to several diseases
ᵇ Gk he
ᶜ Gk him
ᵈ Or Why then did you go out? To see someone
ᵉ Or praised God
ᶠ The denarius was the usual day's wage for a laborer
ᵍ Gk him

October

S M T W T F S
1 2 3 4 5
6 7 8 9 10 11 12
13 14 15 16 17 18 19
20 21 22 23 24 25 26
27 28 29 30 31

October

Monday
21

Tuesday
22

Wednesday
23

United Nations Day

Thursday
24

Friday
25

Saturday
26

Sunday
27

LUKE 7:36-50

She stood behind him at his feet, weeping, and began to bathe his feet with her tears and to dry them with her hair. Then she continued kissing his feet and anointing them with the ointment. (7:38)

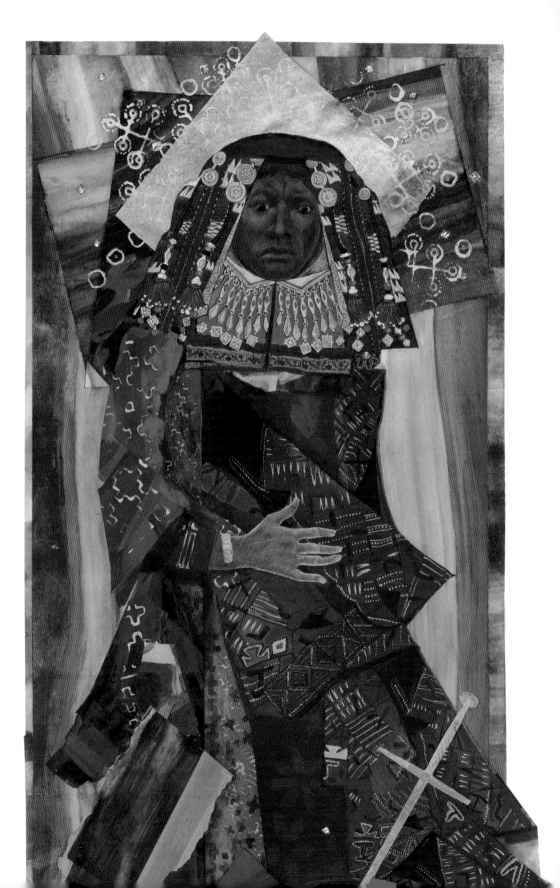

October

S	M	T	W	T	F	S
		1	2	3	4	5
6	7	8	9	10	11	12
13	14	15	16	17	18	19
20	21	22	23	24	25	26
27	28	29	30	31		

November

S	M	T	W	T	F	S
					1	2
3	4	5	6	7	8	9
10	11	12	13	14	15	16
17	18	19	20	21	22	23
24	25	26	27	28	29	30

Labour Day (NZ)

Bank Holiday (Ireland)

Monday
28

Tuesday
29

Wednesday
30

Halloween

Thursday
31

Friday
1

Saturday
2

Sunday
3

REVELATION 12

And she gave birth to a son, a male child, who is to rule all the nations with a rod of iron. But her child was snatched away and taken to God and to his throne. (12:5)

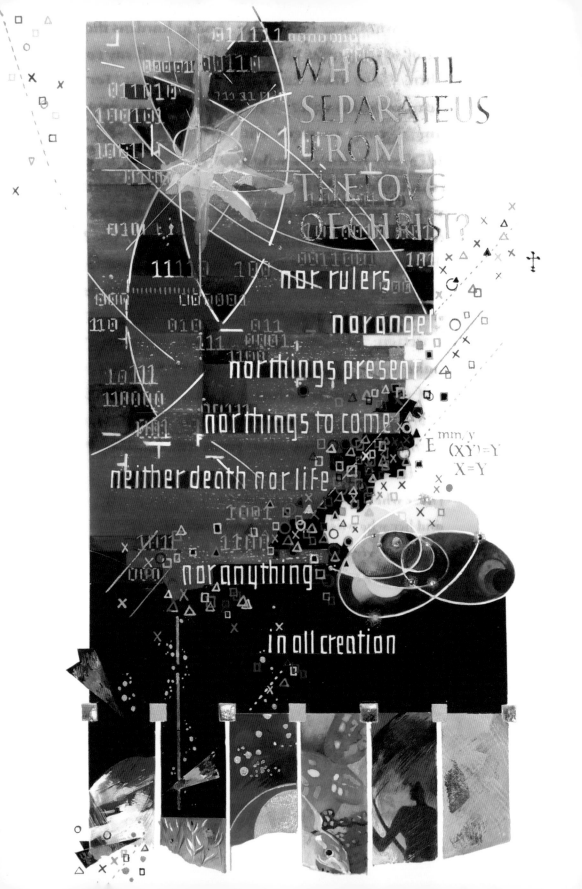

November

S M T W T F S
　　　　 1 2
3 4 5 6 7 8 9
10 11 12 13 14 15 16
17 18 19 20 21 22 23
24 25 26 27 28 29 30

November

Monday
4

Election Day (USA)

Tuesday
5

Wednesday
6

Thursday
7

Friday
8

Saturday
9

Sunday
10

ROMANS 8

Who will separate us from the love of Christ? Will hardship, or distress, or persecution, or famine, or nakedness, or peril, or sword? (8:35)

משלי

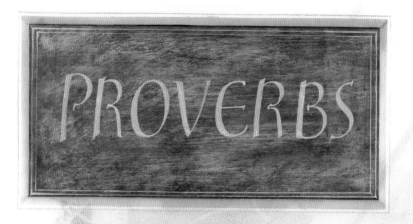

PROVERBS

THE FEAR OF THE LORD
IS THE BEGINNING OF KNOWLEDGE.
FOOLS DESPISE WISDOM AND
INSTRUCTION. HEAR MY CHILD,
YOUR FATHER'S INSTRUCTION,
AND DO NOT REJECT YOUR MOTHER'S TEACHING
KNOWLEDGE

The proverbs of Solomon son of David, king of Israel:

November

S	M	T	W	T	F	S
					1	2
3	4	5	6	7	8	9
10	11	12	13	14	15	16
17	18	19	20	21	22	23
24	25	26	27	28	29	30

November

Veterans' Day (USA)

Remembrance Day (Canada, Ireland, UK)

Monday
11

Tuesday
12

Wednesday
13

Thursday
14

Friday
15

Saturday
16

Sunday
17

PROVERBS

For the Lord gives wisdom; from his mouth come knowledge and understanding. (2:6)

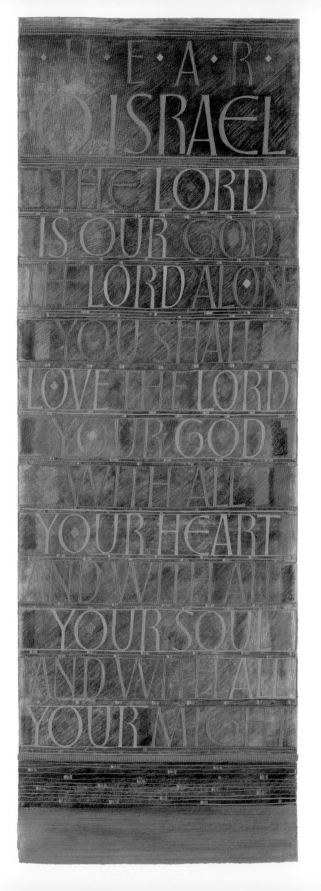

November

S M T W T F S
 1 2
3 4 5 6 7 8 9
10 11 12 13 14 15 16
17 18 19 20 21 22 23
24 25 26 27 28 29 30

November

Monday
18

Tuesday
19

Wednesday
20

Thursday
21

Friday
22

Saturday
23

Sunday
24

DEUTERONOMY 6:4-5

Hear, O Israel: The Lord is our God, the Lord alone. You shall love the Lord your God with all your heart, and with all your soul, and with all your might.

things." When it grew late, his disciples came to
him & said," This is a deserted place, and the hour
is now very late; ³⁶ send them away so that they may
go into the surrounding country and villages and
buy something for themselves to eat." ³⁷ But he an
swered them, "You give them something to eat." They
said to him, "Are we to go and buy two hundred
denarii worth of bread, and give it to them to eat?"
³⁸ And he said to them, "How many loaves have you?
Go and see." When they had found out, they said,
"Five, and two fish." ³⁹ Then he ordered them to get
all the people to sit down in groups on the green
grass. ⁴⁰ So they sat down in groups of hundreds
and of fifties. ⁴¹ Taking the five loaves and the two
fish, he looked up to heaven, and blessed & broke
the loaves, and gave them to his disciples to set be
fore the people; and he divided the two fish among
them all. ⁴² And all ate and were filled; ⁴³ and they
took up twelve baskets full of broken pieces and of
the fish. ⁴⁴ Those who had eaten the loaves numbered
five thousand men. Immediately he made his dis
ciples get into the boat & go on ahead to the other
side, to Bethsaida, while he dismissed the crowd.
⁴⁶ After saying farewell to them, he went up on the
mountain to pray. When evening came, the boat
was out on the sea, and he was alone on the land.
⁴⁸ When he saw that they were straining at the oars
against an adverse wind, he came towards them
early in the morning, walking on the sea. He intended
to pass them by. ⁴⁹ But when they saw him walking
on the sea, they thought it was a ghost and cried
out; ⁵⁰ for they all saw him and were terrified. But
immediately he spoke to them & said," Take heart,
it is I; do not be afraid." ⁵¹ Then he got into the boat
with them & the wind ceased. And they were utterly
astounded, ⁵² for they did not understand about
the loaves, but their hearts were hardened. When
they had crossed over, they came to land at Gennes
aret and moored the boat. ⁵⁴ When they got out of
the boat, people at once recognized him, ⁵⁵ and rushed
about that whole region and began to bring the sick
on mats to wherever they heard he was. ⁵⁶ And wher
ever he went, into villages or cities or farms, they
laid the sick in the marketplaces, and begged him
that they might touch even the fringe of his cloak;
and all who touched it were healed.

7

Now when the Pharisees and some of the
scribes who had come from Jerusalem
gathered around him, ² they noticed that
some of his disciples were eating with defiled hands,
that is, without washing them.³ [For the Pharisees,
and all the Jews, do not eat unless they thoroughly
wash their hands, thus observing the tradition of
the elders; ⁴ and they do not eat anything from the
market unless they wash it; and there are also many
other traditions that they observe, the washing of
cups, pots, and bronze kettles.] ⁵ So the Pharisees
and the scribes asked him, "Why do your disciples
not live according to the tradition of the elders,
but eat with defiled hands?" ⁶ He said to them, "Isaiah
prophesied rightly about you hypocrites, as it is
written,

'This people honors me with their lips,
 but their hearts are far from me;
⁷ in vain do they worship me,
 teaching human precepts as doctrines.'
⁸ You abandon the commandment of God & hold
to human tradition." Then he said to them, "You
have a fine way of rejecting the commandment of
God in order to keep your tradition! ¹⁰ For Moses
said, 'Honor your father & your mother'; and, 'Who
ever speaks evil of father or mother must surely die.'
¹¹ But you say that if anyone tells father or mother,
'Whatever support you might have had from me is
Corban' [that is, an offering to God] — ¹² then you no
longer permit doing anything for a father or mother,
¹³ thus making void the word of God through your
tradition that you have handed on. And you do
many things like this." Then he called the crowd
again and said to them, "Listen to me, all of you,
and understand: ¹⁵ there is nothing outside a person

קָרְבָּן

ᵃ The denarius was the usual
 day's wage for a laborer
ᵇ Meaning of Gk uncertain
ᶜ Other ancient authorities read
 and when they come from the
 marketplace, they do not eat unless
 they purify themselves
ᵈ Other ancient authorities add
 and beds
ᵉ Gk: walk
 Gk: lacks to God

November

S	M	T	W	T	F	S
					1	2
3	4	5	6	7	8	9
10	11	12	13	14	15	16
17	18	19	20	21	22	23
24	25	26	27	28	29	30

December

S	M	T	W	T	F	S
1	2	3	4	5	6	7
8	9	10	11	12	13	14
15	16	17	18	19	20	21
22	23	24	25	26	27	28
29	30	31				

Nov-Dec

*Begins at sundown the previous day

Monday
25

Tuesday
26

Wednesday
27

Thanksgiving (USA)

Hanukkah*

Thursday
28

Friday
29

St. Andrew's Day (UK)

Saturday
30

Sunday
1

MARK 6:33-44; 8:1-10

Taking the five loaves and the two fish, he looked up to heaven, and blessed and broke the loaves, and gave them to his disciples to set before the people; and he divided the two fish among them all. And all ate and were filled. (6:41-42)

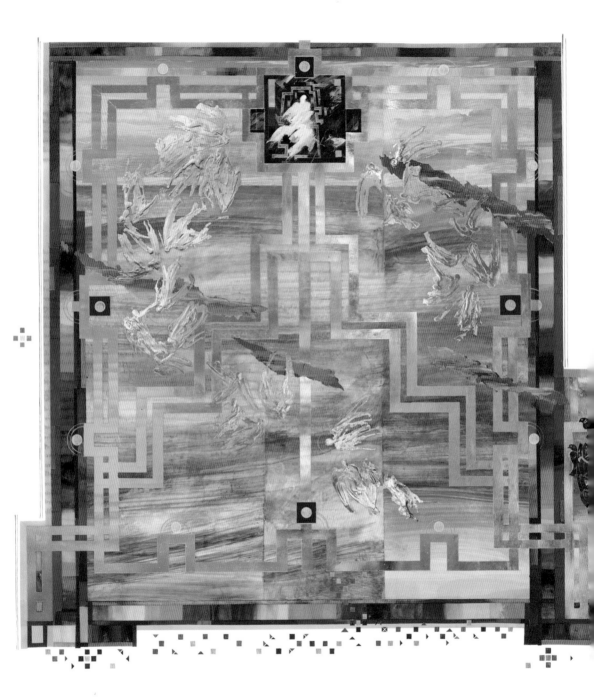

December

December

S	M	T	W	T	F	S
1	2	3	4	5	6	7
8	9	10	11	12	13	14
15	16	17	18	19	20	21
22	23	24	25	26	27	28
29	30	31				

December

St. Andrew's Day (observed) (UK—Scotland)

Monday

2

Tuesday

3

Wednesday

4

Hanukkah ends

Thursday

5

Friday

6

Saturday

7

Sunday

8

REVELATION 7

They cried out in a loud voice, saying, "Salvation belongs to our God who is seated on the throne, and to the Lamb!" (7:10)

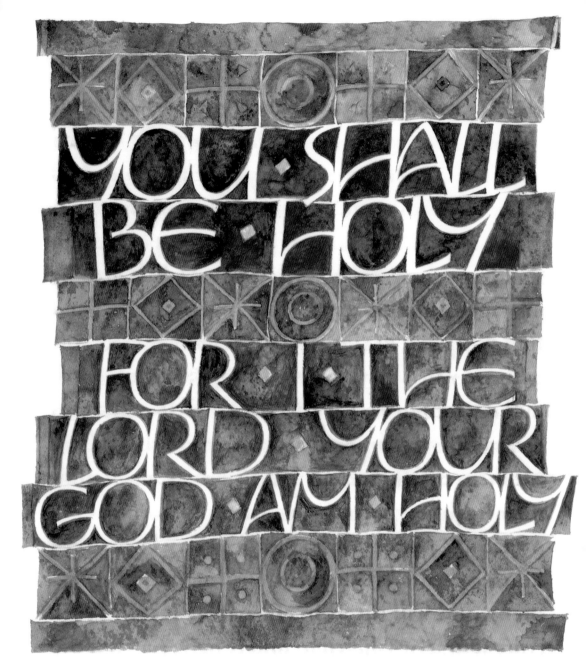

December

S	M	T	W	T	F	S
1	2	3	4	5	6	7
8	9	10	11	12	13	14
15	16	17	18	19	20	21
22	23	24	25	26	27	28
29	30	31				

Monday
9

Human Rights Day

Tuesday
10

Wednesday
11

Thursday
12

Friday
13

Saturday
14

Sunday
15

LEVITICUS 19:2

Speak to all the congregation of the people of Israel and say to them: You shall be holy, for I the Lord your God am holy.

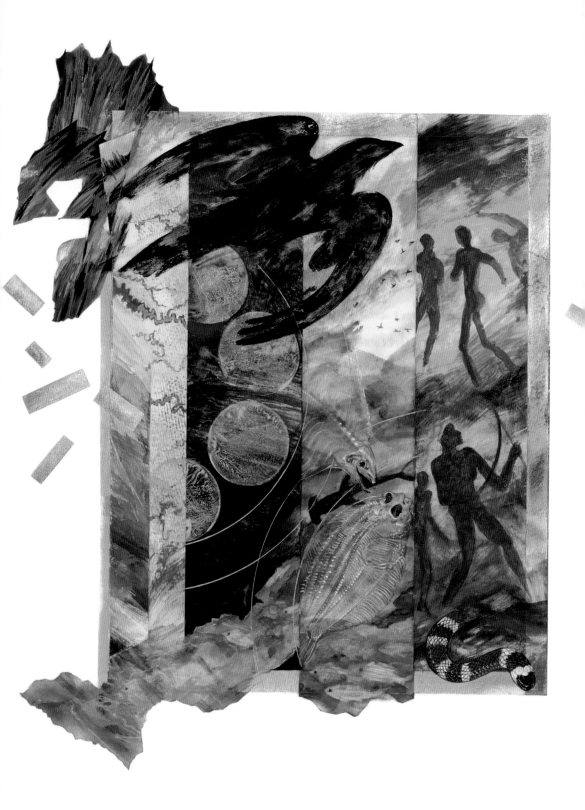

December

S	M	T	W	T	F	S
1	2	3	4	5	6	7
8	9	10	11	12	13	14
15	16	17	18	19	20	21
22	23	24	25	26	27	28
29	30	31				

December

Monday
16

Tuesday
17

Wednesday
18

Thursday
19

Friday
20

Saturday
21

Sunday
22

WISDOM OF SOLOMON 12-13:9

For thy immortal spirit is in all things. (12:1)

GLORY TO GOD
IN THE
HIGHEST
HEAVEN

AND ON EARTH
PEACE AMONG
THOSE WHOM
HE FAVORS!

to give light
to those
who sit in darkness
and in
the shadow
of death

BY THE TENDER MERCY OF
OUR GOD, THE DAWN FROM ON
HIGH WILL BREAK UPON US

December

S M T W T F S
1 2 3 4 5 6 7
8 9 10 11 12 13 14
15 16 17 18 19 20 21
22 23 24 25 26 27 28
29 30 31

December

Monday
23

Christmas Eve

Tuesday
24

Christmas Day

Wednesday
25

Kwanzaa begins (USA)

Boxing Day (Canada, NZ, UK, Australia—except SA)

St. Stephen's Day (Ireland)

Proclamation Day (Australia—SA)

Thursday
26

Friday
27

Saturday
28

Sunday
29

LUKE 2:1-20

And she gave birth to her firstborn son and wrapped him in bands of cloth, and laid him in a manger, because there was no place for them in the inn. (2:7)

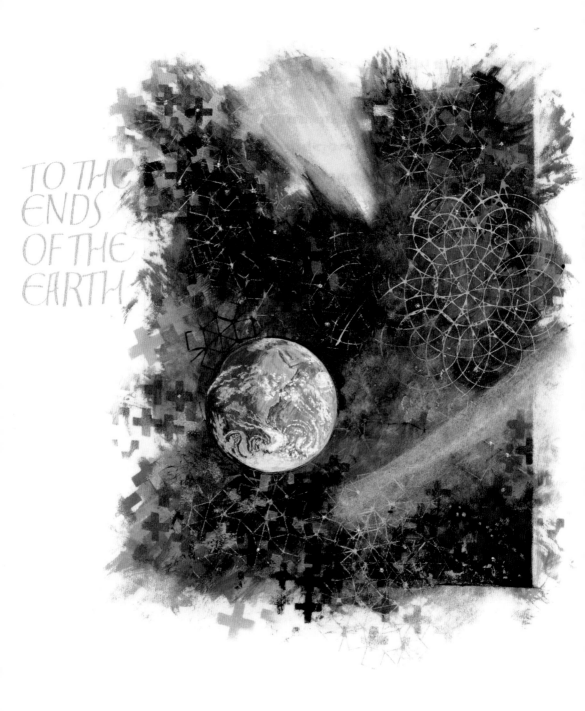

TO THE
ENDS
OF THE
EARTH

December								January 2014						
S	M	T	W	T	F	S		S	M	T	W	T	F	S
1	2	3	4	5	6	7					1	2	3	4
8	9	10	11	12	13	14		5	6	7	8	9	10	11
15	16	17	18	19	20	21		12	13	14	15	16	17	18
22	23	24	25	26	27	28		19	20	21	22	23	24	25
29	30	31						26	27	28	29	30	31	

Dec-Jan 2014

Monday
30

Tuesday
31

New Year's Day

Kwanzaa ends (USA)

Wednesday
1

Bank Holiday (UK—Scotland)

Thursday
2

Friday
3

Saturday
4

Sunday
5

ACTS 1:8

"But you will receive power when the Holy Spirit has come upon you; and you will be my witnesses in Jerusalem, in all Judea and Samaria, and to the ends of the earth."

2014

January

February

March

April

May

June

2014

July

August

September

October

November

December

2012

January
S	M	T	W	T	F	S
1	2	3	4	5	6	7
8	9	10	11	12	13	14
15	16	17	18	19	20	21
22	23	24	25	26	27	28
29	30	31				

February
S	M	T	W	T	F	S
			1	2	3	4
5	6	7	8	9	10	11
12	13	14	15	16	17	18
19	20	21	22	23	24	25
26	27	28	29			

March
S	M	T	W	T	F	S
				1	2	3
4	5	6	7	8	9	10
11	12	13	14	15	16	17
8	19	20	21	22	23	24
25	26	27	28	29	30	31

April
S	M	T	W	T	F	S
1	2	3	4	5	6	7
8	9	10	11	12	13	14
15	16	17	18	19	20	21
22	23	24	25	26	27	28
29	30					

May
S	M	T	W	T	F	S
		1	2	3	4	5
6	7	8	9	10	11	12
13	14	15	16	17	18	19
20	21	22	23	24	25	26
27	28	29	30	31		

June
S	M	T	W	T	F	S
					1	2
3	4	5	6	7	8	9
10	11	12	13	14	15	16
17	18	19	20	21	22	23
24	25	26	27	28	29	30

July
S	M	T	W	T	F	S
1	2	3	4	5	6	7
8	9	10	11	12	13	14
15	16	17	18	19	20	21
22	23	24	25	26	27	28
29	30	31				

August
S	M	T	W	T	F	S
			1	2	3	4
5	6	7	8	9	10	11
12	13	14	15	16	17	18
19	20	21	22	23	24	25
26	27	28	29	30	31	

September
S	M	T	W	T	F	S
						1
2	3	4	5	6	7	8
9	10	11	12	13	14	15
16	17	18	19	20	21	22
23	24	25	26	27	28	29
30						

October
S	M	T	W	T	F	S
	1	2	3	4	5	6
7	8	9	10	11	12	13
14	15	16	17	18	19	20
21	22	23	24	25	26	27
28	29	30	31			

November
S	M	T	W	T	F	S
				1	2	3
4	5	6	7	8	9	10
11	12	13	14	15	16	17
8	19	20	21	22	23	24
25	26	27	28	29	30	

December
S	M	T	W	T	F	S
						1
2	3	4	5	6	7	8
9	10	11	12	13	14	15
16	17	18	19	20	21	22
23	24	25	26	27	28	29
30	31					

2014

January
S	M	T	W	T	F	S
			1	2	3	4
5	6	7	8	9	10	11
12	13	14	15	16	17	18
19	20	21	22	23	24	25
26	27	28	29	30	31	

February
S	M	T	W	T	F	S
						1
2	3	4	5	6	7	8
9	10	11	12	13	14	15
16	17	18	19	20	21	22
23	24	25	26	27	28	

March
S	M	T	W	T	F	S
						1
2	3	4	5	6	7	8
9	10	11	12	13	14	15
16	17	18	19	20	21	22
23	24	25	26	27	28	29
30	31					

April
S	M	T	W	T	F	S
		1	2	3	4	5
6	7	8	9	10	11	12
13	14	15	16	17	18	19
20	21	22	23	24	25	26
27	28	29	30			

May
S	M	T	W	T	F	S
				1	2	3
4	5	6	7	8	9	10
11	12	13	14	15	16	17
8	19	20	21	22	23	24
25	26	27	28	29	30	31

June
S	M	T	W	T	F	S
1	2	3	4	5	6	7
8	9	10	11	12	13	14
15	16	17	18	19	20	21
22	23	24	25	26	27	28
29	30					

July
S	M	T	W	T	F	S
		1	2	3	4	5
6	7	8	9	10	11	12
13	14	15	16	17	18	19
20	21	22	23	24	25	26
27	28	29	30	31		

August
S	M	T	W	T	F	S
					1	2
3	4	5	6	7	8	9
10	11	12	13	14	15	16
17	18	19	20	21	22	23
24	25	26	27	28	29	30
31						

September
S	M	T	W	T	F	S
	1	2	3	4	5	6
7	8	9	10	11	12	13
14	15	16	17	18	19	20
21	22	23	24	25	26	27
28	29	30				

October
S	M	T	W	T	F	S
			1	2	3	4
5	6	7	8	9	10	11
12	13	14	15	16	17	18
19	20	21	22	23	24	25
26	27	28	29	30	31	

November
S	M	T	W	T	F	S
						1
2	3	4	5	6	7	8
9	10	11	12	13	14	15
16	17	18	19	20	21	22
23	24	25	26	27	28	29
30						

December
S	M	T	W	T	F	S
	1	2	3	4	5	6
7	8	9	10	11	12	13
14	15	16	17	18	19	20
21	22	23	24	25	26	27
28	29	30	31			